# DRAWING AUTISM

Every effort has been made to trace accurate ownership of copyrighted text and visual materials used in this book. Errors or omissions will be corrected in subsequent editions, provided notification is sent to the publisher.

Published by Akashic Books
Originally published in hardcover by Mark Batty Publisher in 2009
©2009, 2014 by Jill Mullin
All art and text ©2014 by the respective artists and authors.

Front cover illustrations (top): David Barth, *Vogels*.

Front cover illustrations (bottom): John M. Williams, *Pharaoh, the Face of Eternity*, Esther J. Brokaw, *Winter Trees*, Emily L. Williams, *A Portrait of the Artist*, and Stephen Mallon, from *Tightrope Fiddler*.

Back cover illustrations: Gregory L. Blackstock, *The Art Supplies* and Noah Erenberg, *Hot Deals*.

Designed by Ghost & Company · www.ghostandcompany.com

Cover design by Aaron Petrovich with Ghost & Company

ISBN-13: 978-1-61775-198-1
Library of Congress Control Number: 2013938809

First Akashic Books printing

Printed in China

Akashic Books
PO Box 1456
New York, NY 10009
info@akashicbooks.com
www.akashicbooks.com

# DRAWING AUTISM

## JILL MULLIN

AKASHIC BOOKS

# TABLE OF CONTENTS

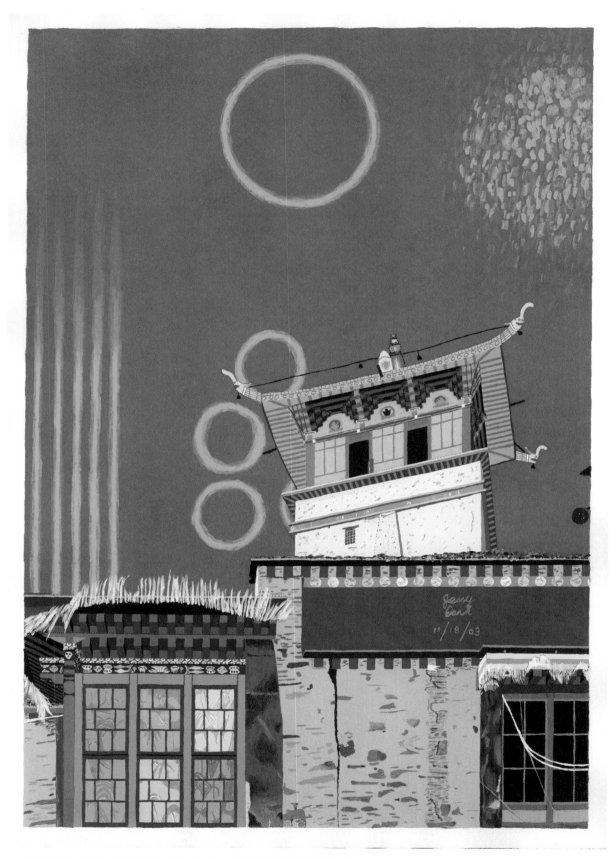

JESSICA PARK: THE POTALA PALACE IN TIBET; 16 X 20 INCHES; 1990. COURTESY OF PURE VISION ARTS.

# NURTURING THE WAYS IN WHICH WE SEE THE WORLD

## BY TEMPLE GRANDIN

When I was a child, my mother nurtured my artistic ability. I was always encouraged to draw many different subjects. As an adult, I used my artistic talent for my business of designing livestock handling facilities. One of the lessons my mother taught me that really helped to develop my skills was to create pictures that other people would want.

In elementary school, I drew many pictures of horses. Individuals on the autism spectrum often become fixated on their favorite things. As a child I would keep drawing the same things over and over. The great motivation of these fixations has been channeled into the creation of all the beautiful art featured in this book.

Talents need to be carefully nurtured and directed. I have heard sad stories of a misguided teacher stamping out a child's interest in art. If a child draws the same cartoon character over and over, one simple way to encourage him or her to draw other subjects is to ask for something that is related to the character. One example would be to draw a house or a car for their favorite character.

Jessica Park (see pages 6 and 124), a famous artist with autism, creates beautiful paintings of houses formed by multicolored geometric patterns. Her mother, Clara Claiborne Park, worked with Jessy to direct her artistic talent to create paintings that other people would want. Some of her early favorite paintings were of electric blanket controls and corporate logos. Today many people buy her paintings of houses, but few people would want pictures of electric blanket controls. Her mother worked to direct her talent to create pictures with broader appeal.

Most individuals on the autism spectrum often excel at one thing, while struggling with something else. The skills are often uneven. I have observed that there are three different types of specialized autistic minds.

The first type is the visual thinker like me. My mind works like Google for images. When I design equipment, I can test run it in my mind like a computer-generated virtual reality. When I draw a piece of equipment, I can see the actual object. My weak area is algebra. Algebra makes no sense because there is nothing to visualize. The artwork of visual thinkers is often quite photo-realistic. I have never done anything resembling impressionist art.

Some people who are visual thinkers can do geometry and trigonometry; they possess the second type of mind: the pattern thinker. Instead of creating photo-realistic pictures in their imaginations, they see patterns and relationships between numbers. It is a more abstract form of visual thinking. I have talked to a great number of these individuals. Some of them have visual processing problems that interfere with their ability to think in photo-realistic pictures. When they are tired, they report that their visual perception can become distorted. It is similar to the distortions that people with migraines experience. Reading is difficult because the print jiggles on the page.

Such visual processing problems in the brain may change their art in beautiful ways. If they do visual art, it may be more abstract and impressionistic, as opposed to photo-realistic. Emily L. Williams (see pages 22–23 and 151–154), in her many books and writings, has explained how she is not a visual thinker—she is an auditory thinker. When I first looked at her work I had expected to see nothing but abstract and impressionistic art. For somebody who claims not to be a visual thinker, she has created a great range of paintings and sculptures. Some of her paintings are very impressionistic and others are not. At the same time, I looked up Claude Monet and saw some of the same soft images with a dream-like quality. Problems with visual processing will vary depending on how tired the person is. Both Emily L. Williams and Monet have a mixture of very abstract impressionist art and more photo-realistic art. Perhaps this is due to changes in their visual perception. Visual processing problems tend to improve or get worse depending on fatigue or sensory overstimulation. Some people have such severe visual processing problems that they cannot draw at all. Out of forty students in my design class, I find at least one in every class who absolutely cannot draw. Many of these students also have difficulty driving at night, reading is hard, and they all hate the flicker of fluorescent lights.

The third type of specialized mind on the spectrum is the word specialist mind. These people are often really good with words, and they usually are not interested in art.

No matter the type of mind, ability has to be nurtured. It took me three years to learn how to design cattle handling facilities. It was not done overnight. Parents, teachers, doctors, and everybody who works with individuals on the spectrum need to help these individuals develop their abilities.

I hope you enjoy the artwork in this book.

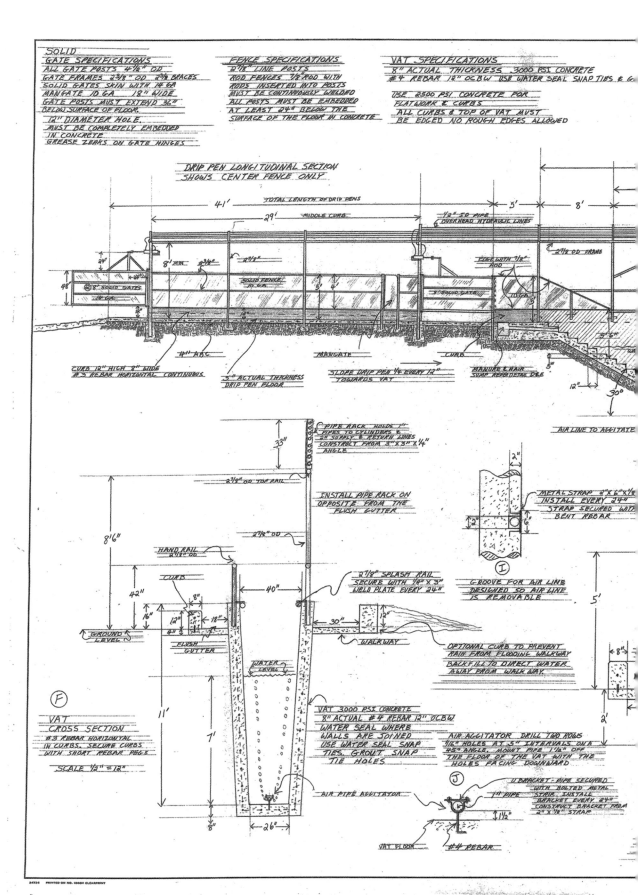

TEMPLE GRANDIN: DIPPING VAT SYSTEM, SIDE VIEW; 1978. COURTESY OF TEMPLE GRANDIN.

# DIPPING VAT SYSTEM Designed by Temple Grandin

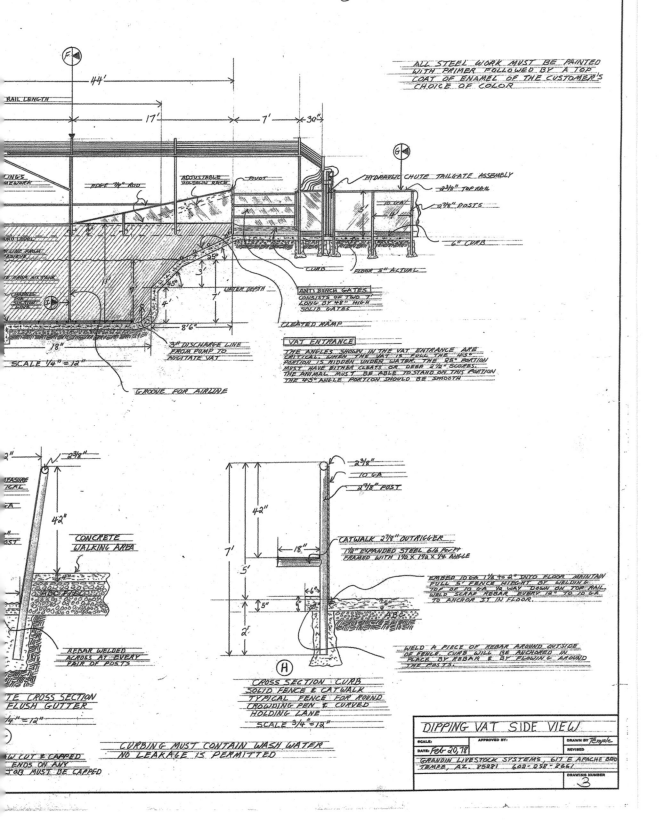

ALL STEEL WORK MUST BE PAINTED
WITH PRIMER FOLLOWED BY A TOP
COAT OF ENAMEL OF THE CUSTOMER'S
CHOICE OF COLOR

44'

RAIL LENGTH

17'        7'       30"

EDGE 7/8" ROD        ADJUSTABLE        PIVOT        HYDRAULIC CHUTE TAILGATE ASSEMBLY
                     HOLDDOWN RACK                  2 3/8" TOP RAIL
                                                    2 3/8" POSTS
                                                    10 GA.
                                                    6" CURB

25°
3'
45°                  WATER DEPTH
11'                                CURB       FLOOR 5" ACTUAL
            4'            7'
                                   ANTI BUNCH GATES
8'6"                               CONSISTS OF TWO 7'
                                   LONG BY 48" HIGH
18"                                SOLID GATES
SCALE 1/4"=12"
                                   CLEATED RAMP
      3" DISCHARGE LINE
      FROM PUMP TO                  VAT ENTRANCE
      AGGITATE VAT
                                   THE ANGLES SHOWN IN THE VAT ENTRANCE ARE
      GROOVE FOR AIRLINE           CRITICAL. WHEN THE VAT IS FULL THE 45°
                                   PORTION IS HIDDEN UNDER WATER. THE 25° PORTION
                                   MUST HAVE EITHER CLEATS OR DEEP 2 1/2" SCORES.
                                   THE ANIMAL MUST BE ABLE TO STAND ON THIS PORTION
                                   THE 45° ANGLE PORTION SHOULD BE SMOOTH

2 3/8"                    2 3/8"
                         10 GA
MEASURE                  2 3/8" POST
ACTUAL
              42'
                         42"
                                   7'        CATWALK 2 3/8" OUTRIGGER
POST                                         1 1/2" EXPANDED STEEL 6lb PER SQ.FT.
                                             FRAMED WITH 1 1/2 x 1 1/2 x 1/4 ANGLE
      CONCRETE
      WALKING AREA           18"
                         5'          EMBER 10 GA 1 1/2 to 2" INTO FLOOR. MAINTAIN
                                     FULL 5' FENCE HIEGHT BY WELDING
                                     TOP OF 10 GA 1/2 WAY DOWN ON TOP RAIL.
                         6"          WELD SCRAP REBAR EVERY 12" TO 10 GA
                         5"          TO ANCHOR IT IN FLOOR.
                         2'
      REBAR WELDED
      ACROSS AT EVERY                WELD A PIECE OF REBAR AROUND OUTSIDE
      PAIR OF POSTS                  OF FENCE. CURB WILL BE ANCHORED IN
                                     PLACE BY REBAR & BY FLOWING AROUND
                                     THE POSTS.
TE CROSS SECTION
FLUSH GUTTER            CROSS SECTION CURB
                       SOLID FENCE & CATWALK
1/4"=12"               TYPICAL FENCE FOR ROUND
                       CROWDING PEN & CURVED
                       HOLDING LANE
                       SCALE 3/4"=12"
W CUT & CAPPED
ENDS ON ANY     CURBING MUST CONTAIN WASH WATER
JOB MUST BE CAPPED   NO LEAKAGE IS PERMITTED

DIPPING VAT SIDE VIEW

SCALE:          APPROVED BY:              DRAWN BY Temple
DATE: Feb 20,78                           REVISED

GRANDIN LIVESTOCK SYSTEMS, 617 E APACHE BLVD
TEMPE, AZ. 85281    602-258-8661

DRAWING NUMBER
3

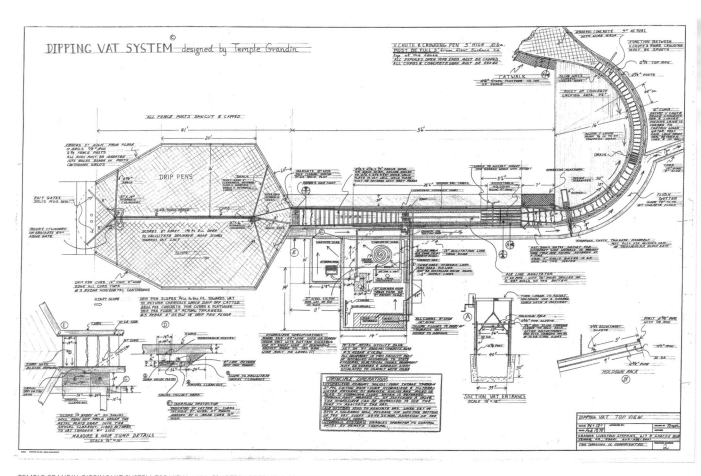

TEMPLE GRANDIN: DIPPING VAT SYSTEM, TOP VIEW; 1978. COURTESY OF TEMPLE GRANDIN.

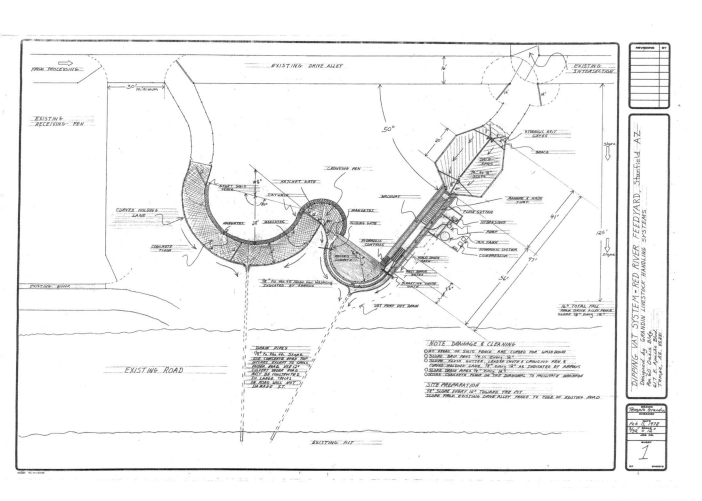

TEMPLE GRANDIN: DIPPING VAT SYSTEM; 1978. COURTESY OF TEMPLE GRANDIN.

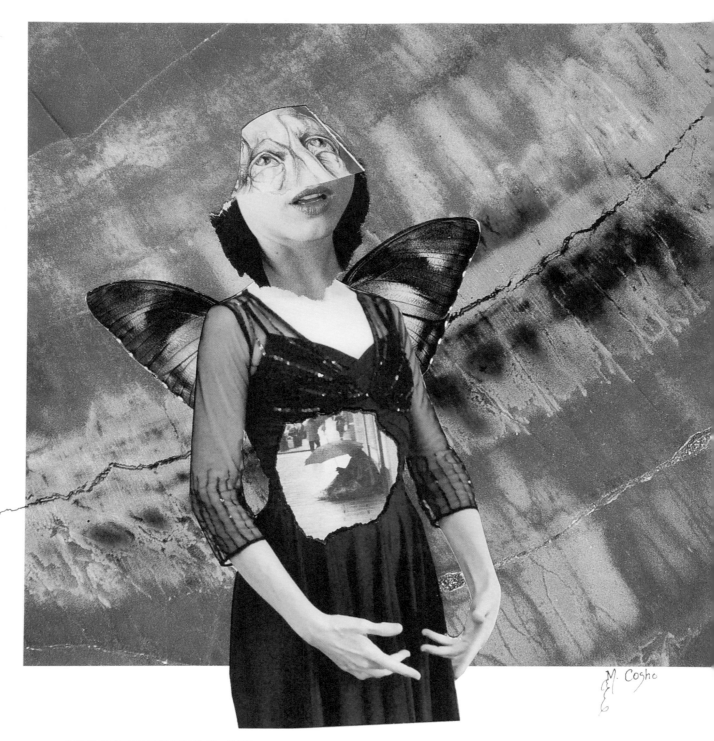

MARILYN COSHO: WORST FEAR; COLLAGE; 8 X 11 INCHES; 2009.

# AS SEEN THROUGH THE AUTISM SPECTRUM

## BY JILL MULLIN

Autism spectrum disorder (ASD) is a developmental disability associated with social interaction, communication impairments, and rigid and/or repetitive behaviors. An individual diagnosed on the autism spectrum can experience a variety of symptoms, all varying in severity; hence the term "spectrum" in the disability's title. An individual can be diagnosed with Pervasive Developmental Disorder (NOS) [Not Otherwise Specified], Autistic Disorder, or be diagnosed with Asperger's Disorder, all of which fall on the autism spectrum. As of 2012, according to the Center for Disease Control, 1 in 88 children are diagnosed with ASD, which affects individuals from all socioeconomic, racial, and ethnic groups; boys are approximately five times more likely than girls to be diagnosed with the disorder.

Because of the increase in diagnosis over recent years, ASD has experienced increased media attention. Films, TV shows, books, magazines, and newspaper articles have examined the disability in order to increase autism awareness, explore current research and epidemiology, and to examine daily living of individuals affected by the disorder. Because ASD is a spectrum disorder, disabilities as well as abilities and talents can vary from individual to individual. Commonly in the media, individuals with autism have been shown to have great talents in certain areas such as science and math. The intention of this book is to display another area where individuals with autism can have great abilities. Fostering and nurturing abilities despite a diagnosis can help individuals with ASD discover their talents.

Four years ago, when the first edition of *Drawing Autism* was released, I was not sure who the audience would be. Would it be individuals with autism? Their families? Artists? As it turns out, the book has universal appeal. I received feedback from people all over the world from various professional and personal backgrounds. There were comments and interest from galleries and museums, cultural institutions, social service providers, personal blogs, and the mainstream media. It was extremely exciting and, honestly, quite unexpected.

The book's contributors also expressed enthusiasm. For many of them, it was a thrill for their work to be included in a book that was available all over the world. Some of these artists have told me how they were able to use the book to develop their careers.

Since the initial release of *Drawing Autism*, David Barth has sold his work in galleries and was invited to Beijing where he was featured in an exhibit at the Inside-Out Art Museum. When I first met

Justin Canha, his charcoal illustrations and remarkably detailed small-scale drawings had already been recognized in arts circles, but in the intervening years he has furthered his career as an artist. In 2011, Justin was the subject of a feature in the *New York Times* about an individual with autism trying to develop his identity as an adult.

It is wonderful that the artists in this book have been embraced and served as inspiration to others by way of *Drawing Autism*. Regardless of whether or not the book's contributors sell their work or receive media attention, the very fact that their work exists is what deserves to be most celebrated. This is thanks to their individual talents, passions, and compulsions, and the families and friends who surround them and encourage this mode of expression.

*Drawing Autism* began with an artist named Glen Russ. At an early age, Glen developed a passion for music and drawing, and was also diagnosed with autism. I met Glen at a residential group home in New York City where he lives with five other men with varying disabilities. During the first two years I worked with Glen, every week he would draw many pictures of his favorite bands, like the Jackson 5, the Temptations, and the Whispers. His stylistic stick figures depicting the bands were drawn singing, dancing, or playing instruments as if they were caught in a snapshot from *The Ed Sullivan Show*.

For two years I cheered Glen on. Every day that I saw him I asked, "Did you draw any pictures today?" If he had, he would display his work proudly (often, the drawings from the day would be held together with numerous staples, variously deployed across the paper). Each day that I saw Glen's drawings I would ask, "Can I take one home with me?" He would shrug his shoulders and reply, "Ahhh, no." And so this scene played out for two years until one day Glen finally answered, "Why yes, you can have it!" I was delighted; I put the drawing on my refrigerator for family and friends to enjoy.

While Glen's art was displayed in the fine art gallery otherwise known as my kitchen, I had many casual observers comment on it. Guests who would pass through my home inevitably remarked on the unique images and asked about the artist and his inspirations. Their questions sparked my interest to look into other artists with autism, as it became clear to me that there must be others with a unique perspective as well.

As a professional with many years of schooling and experience working in the field with children and adults diagnosed with autism, I am well versed in the eclectic and compelling ways in which the minds of autistic people work. But for laypeople, for those who have only ever heard of the condition, it is harder to really drive home the varied nature of ASD. The purpose of *Drawing Autism* is to provide visual clues as to how the individuals featured in this book, only a sampling of autistic people, interact and react to the world.

The chapters are organized by themes I identified as I spent more and more time with the submissions. My clinical background in Applied Behavior Analysis (ABA) helped me in sorting out the work so that it provides an overview of the spectrum while showcasing the creative individuality of every single person on the spectrum. These themes and visual tendencies do speak to aspects of the diagnoses. For example, it is common for individuals with autism to become "obsessed" or engage in repetitive behaviors, hence the chapter "Repetition, Repetition, Repetition." Repetitions in the use of numbers, letters, or overall patterns is a trait that some individuals with autism exhibit. Hyperlexia, a psychological syndrome observed in some individuals with autism, is the fascination with letters and numbers often accompanied by an extraordinary ability with written words that can exceed expectations in relation to chronological age. Some of the artwork in "Repetition, Repetition, Repetition" includes this patterned use of letters and numbers. This chapter also includes recurring themes. Some of the artists will recreate the same exact image thousands of times, where other artists will take a favorite theme, such as Shawn Belanger (pages 42,43,58,59,78), who enjoys creating work that represents green space or the outdoors.

In the chapter "Interaction, Individual and Societal," many pieces depict isolationism. Some of the artists express difficulty and frustration in relation to interacting with people in general or with individuals who do not understand autism. This chapter represents human, cultural, and societal interaction struggles that the artists felt while creating their work.

"Another World" is a chapter that deals with mythical places. The artists were compelled to create these new worlds. Some of the artists dreamed of new places when their homes and lives made them feel as if escape was the best option. The chapter celebrates the artists' creativity and imagination.

"Bird's-Eye View" surveys meticulously detailed landscapes. In some cases every ray of sunlight is accounted for or every autumn leaf is aflame with color. The detail and beauty related to the scenes can help us appreciate how some of the artists may see their world every day.

"Getting From Here to There" explores the theme of transportation. It became apparent through the submission process that many artists were interested in transportation hubs as well as vehicles. Every day, all over the world, most people ride some mode of transportation. The work in this chapter marvels at the act of a machine—whether a bicycle or a trolley—transporting us from one place to another. For some of the artists, transportation represents the ability to simply watch the world go by.

"It's All History" focuses on work that the artists created because of their interest in the past.

"Art for Art's Sake" is an extremely important chapter because some of the artists completed their work for no other reason than the act of creation. Not each piece of artwork displayed in the book can be linked directly to a characteristic of autism. Some of the artists reported that they felt a compulsion to create something beautiful and emotional. There are many artists represented in this book, and where and why they create what they create originates from very individualistic experiences.

When an artist was selected for *Drawing Autism* they were asked to complete a questionnaire. Some of the artists were able to answer the questionnaire completely and independently and are quite introspective in terms of their creative process. Others needed some assistance with either reading or writing the answers; parents, friends, or caretakers interviewed some of them. Still others were unable to understand the questions and struggled to answer questions that asked them to introspectively examine their process of art making. Some artists in the book are completely nonverbal and are unable to tell us anything about their work. The content derived from the questionnaire is used throughout the book to have the artists describe their work and their process. All of the contributors received these questions:

**At what age did the act of creating art enter into your life?**
**Why did you start creating art?**
**What inspires/excites you about creating art?**
**How do you choose your subjects? Why do you paint/draw what you do?**
**Do you think your art helps others understand how you view the world?**

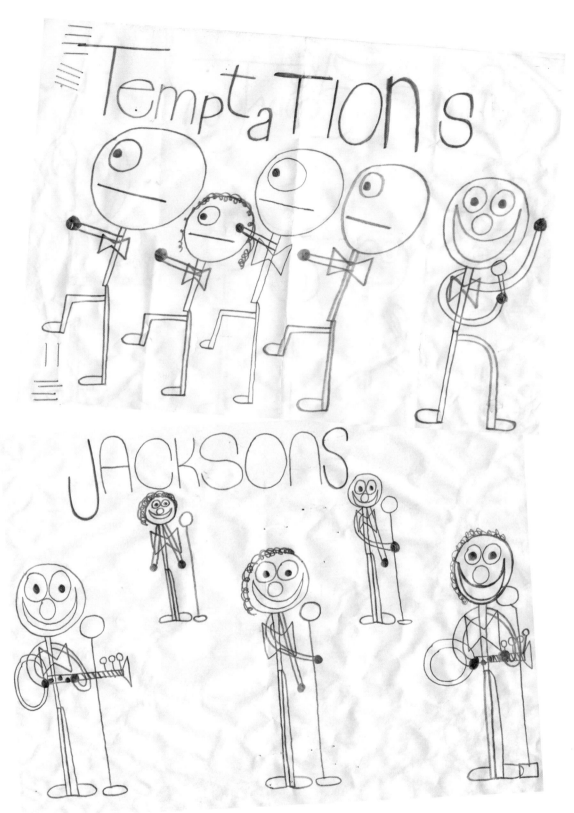

GLEN RUSS: THE TEMPTATIONS (TOP), THE JACKSON 5 (BOTTOM); PENCIL; 8½ X 11 INCHES; 2007.

**Who are some artists that you like?**
**What was the inspiration of each piece of art that you have submitted to**
***Drawing Autism*?**
**Anything else you'd like to say about your artwork?**

Answers to these questions accompany the works and have been written by the artists, or in instances when the artist is unable to write, written by a parent or guardian. I wanted to make sure that the artists expressed their thoughts about their work and their lives on their own terms, in their own voices. I have culled out the most intriguing and insightful of the responses in order to enhance the artists' work and enrich this visual portrait of ASD.

Inspired by artists like Frida Kahlo and Paul Gauguin, as well as by the seemingly mundane everyday occurrences that most of us hardly pay attention to, the work draws from myriad influences and inspirations, filtered through the eyes, minds, and hands of these remarkable people.

The overwhelming number of submissions I received from all over the world astounded me. There were those already established in the art world, while many others used art as an aspect of identity—where words often fail, the visual can be used to communicate. Some of these artists have drawn and painted since they were old enough to pick up a crayon, but others came to art later in life; the tactile act of finger painting induces a calming effect for some; for some the compulsion to create illustrations is simply that—an inexplicable urge that must be satisfied.

The artists in this book are from all over the world and their lives have been shaped by very different experiences. However, there was one common theme despite cultural and geographical differences: many of them compliment the encouragement they have received from their families and their friends. Art has helped many of these people gain confidence that has helped them enjoy life more. Without the encouragement of parents, friends, and teachers, some of them never would have gained the confidence to even try and create, never mind share their work with a critical world.

Though *Drawing Autism* is not a clinical book, it is a remarkable example of how important it is to nurture expressive forms of communication—a lesson worth bearing in mind in general. In these pages, we see how the contributors engage, filter, and interact with the world. For some of them it is the only way that others know what they are thinking.

In researching this book and looking through stacks of submissions, I learned that not only do people with autism have unique visions, but their creativity and talent is boundless. As can be seen in the chapters to follow, there are some unifying themes common amongst the artists, but the message of the book is clear: individuals with autism have a spectrum of talent as well as a spectrum of creativity.

A note on the captions and artist answers:

The captions provide as much information as possible about each piece of art. In instances where certain information was unavailable or unknown the captions reflect that. I have noted when artwork was created by an artist no older than sixteen. I have also identified all instances when the artists have not answered the questions themselves.

KAY AITCH: DISTRACTION FROM THE EYES; PENCIL AND INK.

# INTERACTION, INDIVIDUAL & SOCIETAL

## CHAPTER ONE

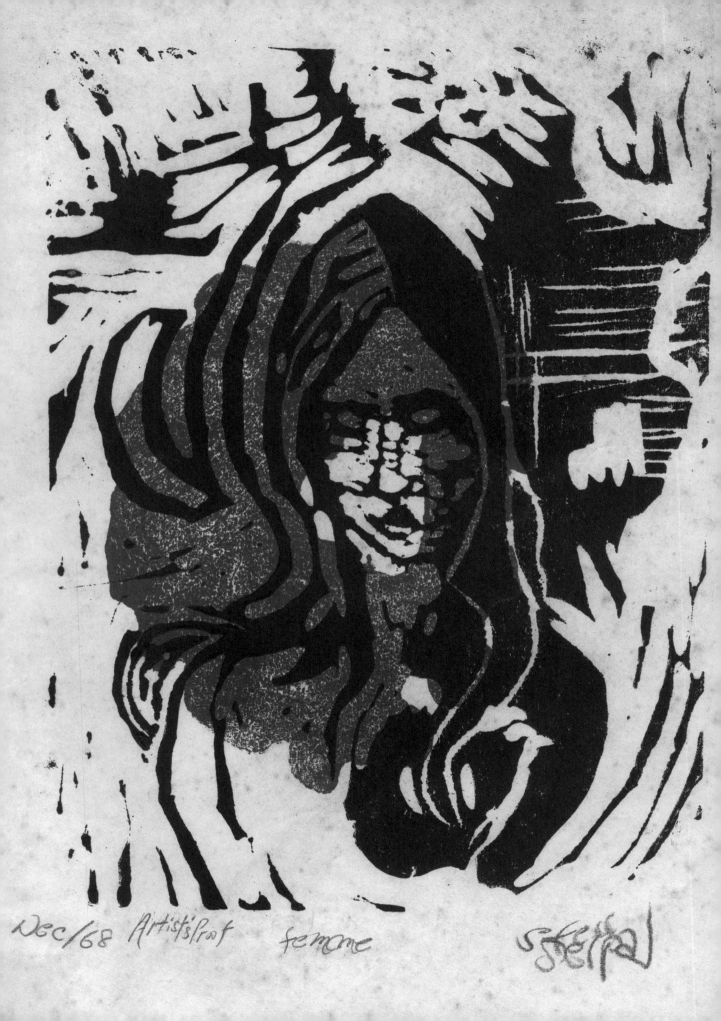

Dec/68 Artist's Proof     femme

STEVEN SANDOR SELPAL: FEMME; TWO-COLOR LINOCUT BLOCK PRINT ON PAPER; 8½ X 11 INCHES; 1968.

**What was the inspiration for this piece?**
This linocut was done at Bealart in London, Ontario. High school students could major in fine art and commercial art. I attended from September 1966 until June 1970. The final year was a grade 13, or Special Arts Certificate, where I majored in sculpture and earned money as a work-study ceramics technician, firing kilns and mixing clay for both ceramics and plaster casting. This linocut was done six months after I started speaking without stammering or forgetting what I was saying. This is one of my earliest works that remain with me.

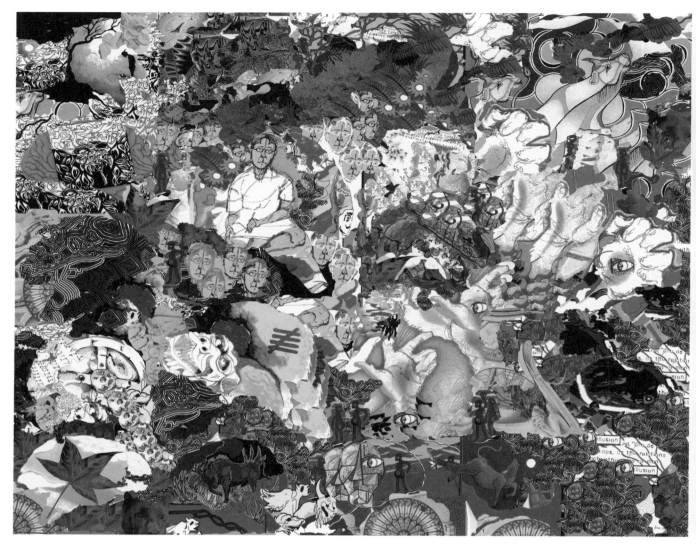

EMILY L. WILLIAMS: A PORTRAIT OF THE ARTIST; MIXED MEDIA; 5 X 4 FEET.

### What was the inspiration for this piece?

This piece is so large, with so many different media, and so many single moments of inspiration, I can't possibly remember all of them. The larger piece is meant to represent my autism; it appears to include just about everything, from gargoyles to leaves to hands to numbers to cows; the list goes on. And the media used to render the piece are just as varied, from ink to scratchboard. The piece is also meant to show, in part, how my brain works when it comes to art. There's nothing hugely symbolic, most of it is what it looks like. The subjects may also appear random and one may wonder why they've been included. Sometimes I didn't know myself. All I knew was that I wanted to draw them; somehow it was about autism (though don't ask me how), and needed to be included. My art is all about the visual and if I thought it looked good in the piece, it was included. That's what my autism is: all of these random parts in my life, memories, likes, dislikes, emotions, everything thrown together into one brain. Sometime there's an obvious reason; sometimes there's not.

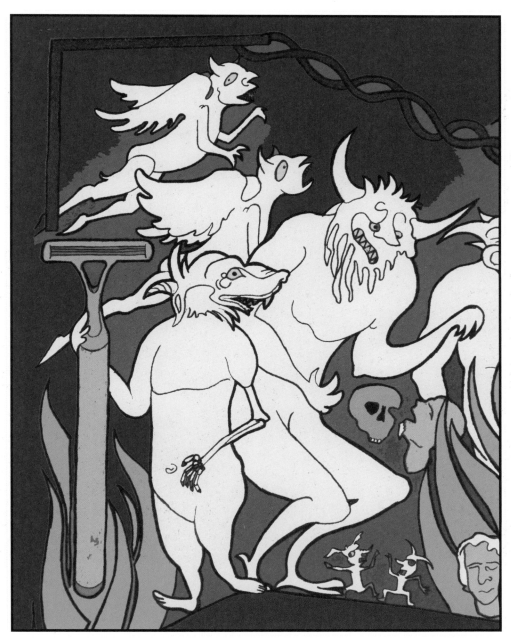

EMILY L. WILLIAMS: THEY TAKE AWAY YOUR RAZORS, YOUR SHOELACES & YOUR BELT; PRISMACOLOR PENCILS WITH PHOTOSHOP WORK.

**What was the inspiration for this piece?**

This is a small portion of a larger piece that's yet to be completed. The larger piece is one of three in a series, focusing symbolically on psychiatric units, utilizing hell as an analogy. The demons in the piece were inspired by twelfth-century works depicting hell and the Final Judgment. The piece was also inspired by some of my own hospital stays in the past. While I was never a suicide risk, I always found it odd that none of the patients could have any of the items listed in the title of this piece. I understood the logic and the risk to suicidal patients, but nevertheless still found it strange to be walking around in shoes with their tongues hanging out or to have unshaven legs.

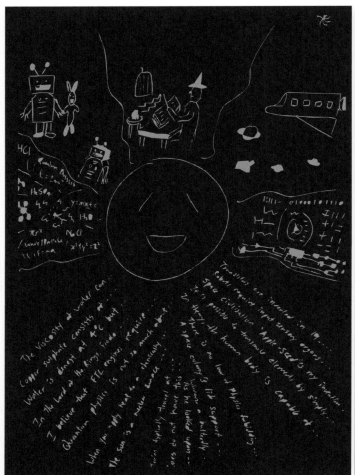

ERIC CHEN: MIRROR MIND POSTER 1, 2, 3, 4 (L–R); 2005.

**What was the inspiration for the *Mirror Mind* posters?**
I created these posters to commemorate and promote the launch of my self-published autism book, *Mirror Mind*. The book aims to convey the inner feelings I feel as a person with autism, and each of the pictures represents a poem from the book.

**What inspires/excites you about creating art?**
Art gives me a way to speak deeply with other people without using words.

# Der Panther

His only view is of the passing bars,
so weary that it holds nothing more.
To him there are a thousand bars
   before him
and behind them, no world.

The soft gear of his strong pliant steps
in the very smallest of circles revolves
like a dance of power around the
   center
where a great will, paralyzed, stands.

Sometimes the curtain of the pupil
   pushes itself
silently upward--. And an image enters,
its tense quiet moves throughout the limbs
into the beating heart, ceases,
   and dies.

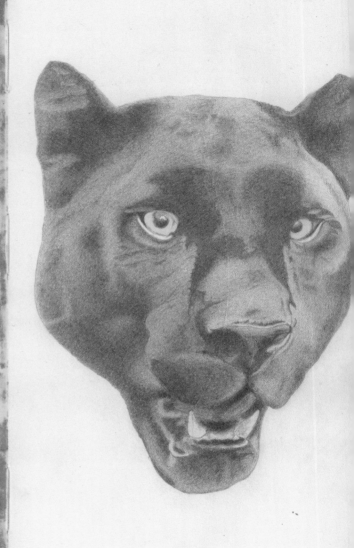

EMILY L. WILLIAMS: PANTHER; PRISMACOLOR PENCILS AND GRAPHITE; 5 X 8 INCHES; 2008.

**What was the inspiration for this piece?**
I was interested in translating poems by Rainer Maria Rilke at the time and one of his best-known, "Der Panther," served as inspiration for the piece. In my sketchbook, it lies facing my translation of Rilke's classic.

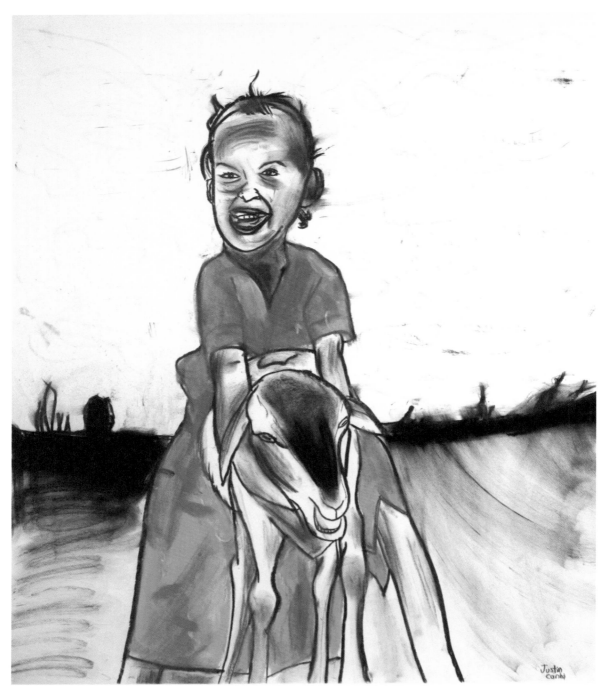

JUSTIN CANHA: GIRL AND GOAT; CHARCOAL AND PASTEL; 2008.
COURTESY OF DR. ROSA C. MARTINEZ/STROKES OF GENIUS, INC.

**At what age did the act of creating art enter into your life?**
When I was five years old.

**Why did you start creating art?**
Because I like cartoon characters.

**What inspires/excites you about creating art?**
Because that's my talent.

**How do you choose your subjects?**
That's my talent.

**Do you think your art helps others understand how you view the world?**
I don't know.

**What was the inspiration for these pieces?**
I got it from my brain.

**Anything else that you'd like to say about your artwork?**
I don't know.

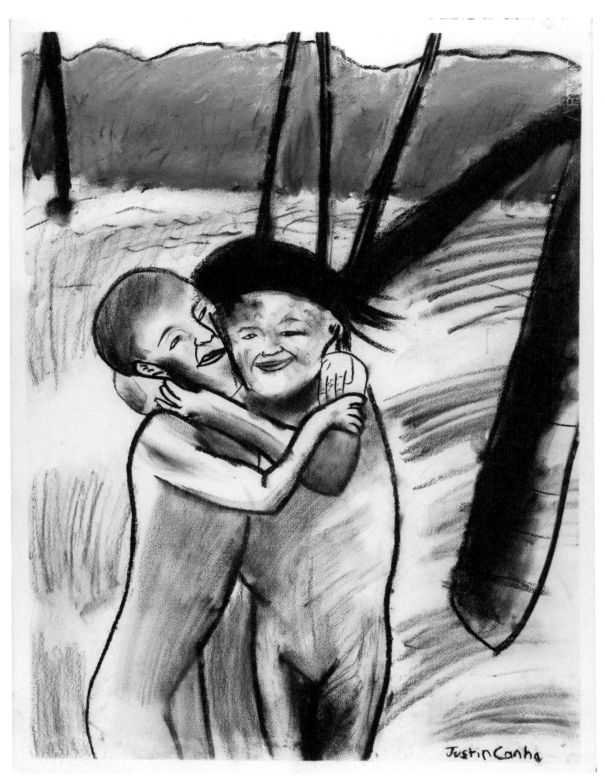

JUSTIN CANHA: AMAZON BOYS IN THE WOODS; CHARCOAL AND PASTEL; 2005 (AT AGE 15).
COURTESY OF DR. ROSA C. MARTINEZ/STROKES OF GENIUS, INC.

JUSTIN CANHA: STOP THAT SNEEZING; 2006.

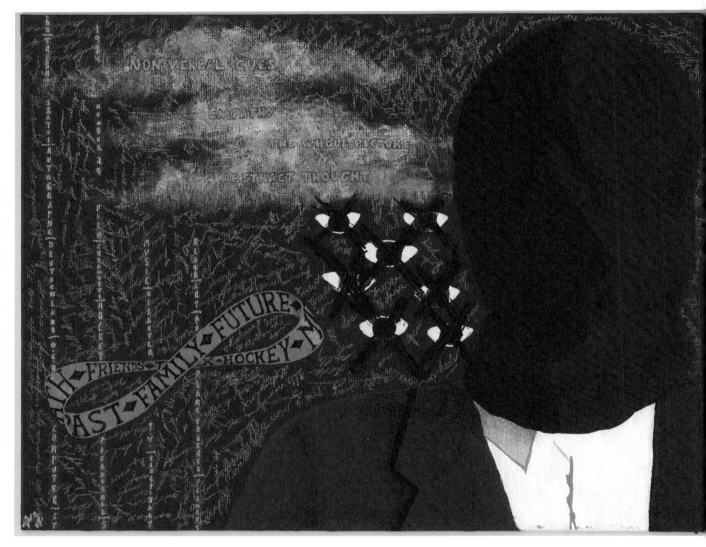

J.W. BRIDGES: WHAT A.S. LOOKS LIKE; ACRYLIC; 11 X 14 INCHES; 2008.

**What was the inspiration for this piece?**

Hopefully this painting will help people with Asperger's syndrome or the loved ones who know someone with AS. I hope it not only helps people to understand, but to comfort them as well. I want to let them know that they are not alone. It is my most personal piece to date. The bag over the head, inspired by The Mars Volta's album *Frances the Mute*, is to show how I feel alone with Asperger's. The Möbius strip for continuous thoughts; the eyes crossed out for the feeling of always being watched and the difficulty of making eye contact. The silver text represents my narrow and intense interests. The clouds show what people with AS struggle to see. And the scribblings are the thoughts and phrases that were in my mind when I painted this.

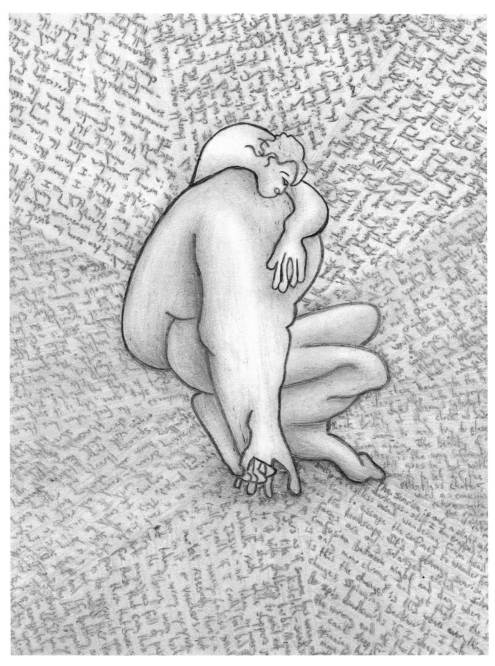

KAY AITCH: LOST IN THOUGHT

### What inspires/excites you about making art?
Everything around me inspires me to create art. What inspires me about creating art is the process of making marks, the feel of things, the seeing shapes and patterns in things.

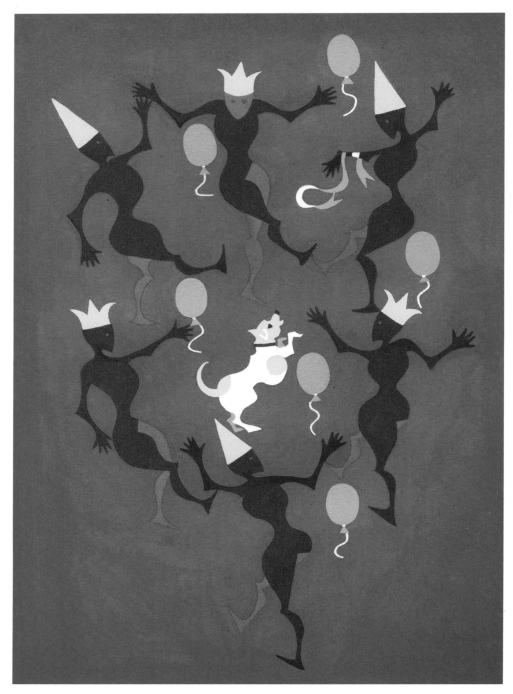

ELENI MICHAEL: DANCING WITH THE DOG; GOUACHE; 7¾ X 12 INCHES; 1995.

**What was the inspiration for this piece?**
This was painted in 1995, not long after I had moved into a housing project for people with special needs. I was euphoric about my new home—a self-contained flat surrounded by a huge garden in a rural setting. (This idyll did not last long.) I brought my dog Jasper with me. He was the only lively animal there and brought great pleasure to me and all of the residents in the project. They loved him too and enjoyed playing with him and petting him. Jasper was a healthy presence and completely indiscriminate with his friendships.

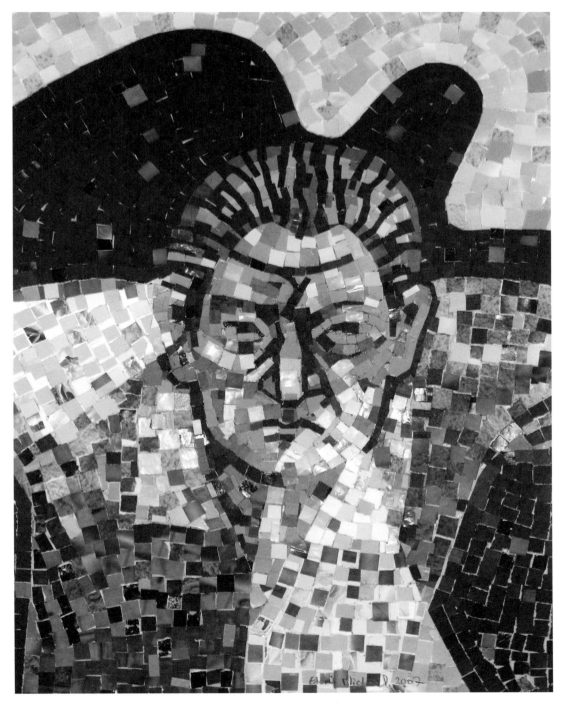

ELENI MICHAEL: ANGEL OF DEATH; PAPER COLLAGE; 14 X 17 INCHES; 2007.

**What was the inspiration for this piece?**
I did this a year after my father died. I did not know how I felt and therefore could not cry or express my feelings to anyone. It has taken years for me to be able to do this. The man in the picture is my father as he looks up and sees the Angel of Death coming to claim him. He is afraid and angry, as he is not ready to go. Dad died alone, unexpectedly while on his piece of mountain in Cyprus, the country of his birth. None of us had the chance to say goodbye and tell him how much he was loved.

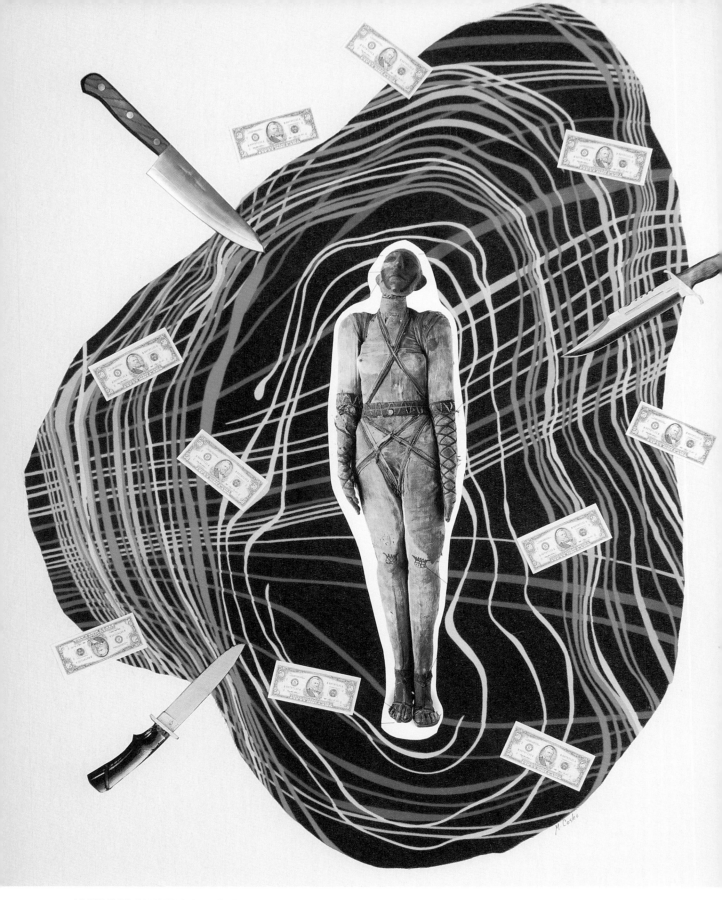

MARILYN COSHO: ALL ABOUT MONEY; MIXED MEDIA; 16 X 20 INCHES; 2009.

**What was the inspiration for this piece?**
This collage represents the paralyzing fear of being laid off. Finding and maintaining a job is difficult enough. Losing a job can feel like a death sentence. There are presently few resources to help adult "Aspies."

**How do you choose your subjects?**
Most of my collages begin with an intangible, overwhelming feeling that I then try to concretely represent. My collages are vast feelings caught in a visual second. The impulse originates from some pre-language, primordial place. Usually the idea/feeling lies dormant for a long time. I like to create because I am most at ease in a self-absorbed state and art is my most direct form of self-expression. It helps me affirm my identity, which I for so long did not understand.

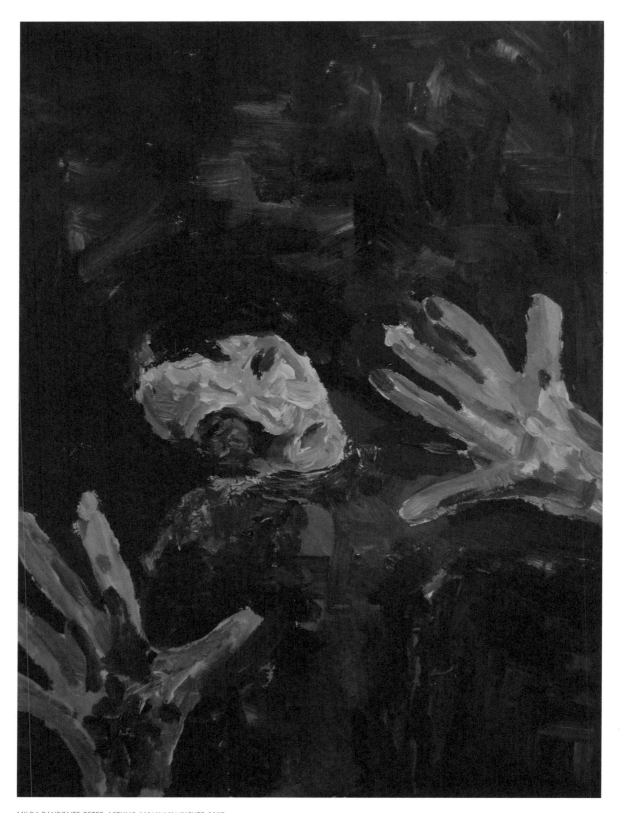

MILDA BANDZAITE: PETER; ACRYLIC; 11¾ X 16½ INCHES; 2007.

**What was the inspiration for this piece?**
This is my first try to paint Peter Spilles (of the German band Project Pitchfork). It wasn't necessary to show a person who really looks like Peter. It was only my emotions after our first meeting: happiness and sadness.

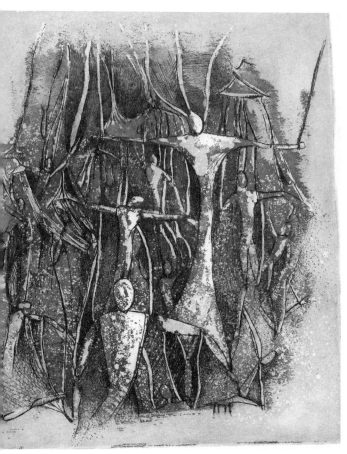
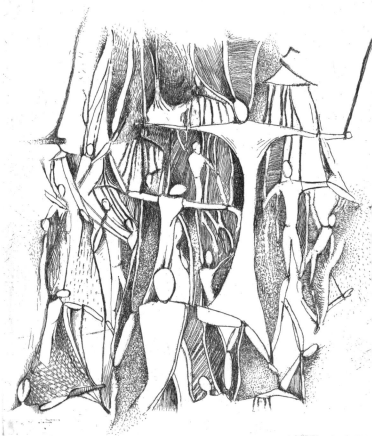

MILDA BANDZAITE: LIFE CONTROL, I AND II; ETCHING AND AQUATINT; 6¾ X 7¾ INCHES; 2008.

**What was the inspiration for these pieces?**
These were inspired by knowing that people control each others' lives. They are like marionettes: one controls the other. It's like theater and people are only the dolls in the hands of others. Also, they limit their lives with their own absurd rules.

RACHEL MARKS: METAPHOR(ICAL) MAZE; COLLAGE AND COMPUTER GRAPHICS; 16½ X 23½ INCHES; 2008.

**What was the inspiration for this piece?**

Figurative language enriches and supports the neurotypical experience. With autism, these purported props and supports to understanding become barriers and frustrations. In this piece I have tried to use neurotypical ways of talking about life—as a maze or a game—to highlight the hurdles such everyday phraseology presents when living with autism. However, the "Metaphor(ical) Maze" is never the only hurdle to surmount: moods, emotions, and senseory processing issues appear to conspire in an attempt to impede our progress.

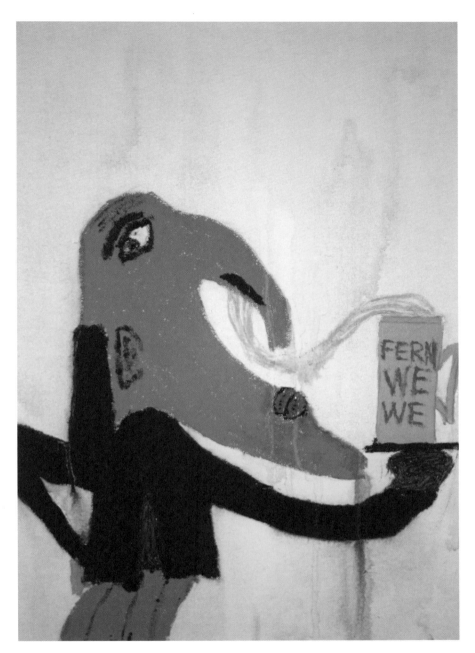

ROBERT MAXWELL: PERCY PONCE HAVING A PINT; OIL; 11¾ X 16½ INCHES; 2009.
COURTESY OF THE NATIONAL AUTISTIC SOCIETY, UK.

**What inspires/excites you about creating art?**

I like to caricature people who have put me down, but beautiful scenery and fine buildings also inspire me.

I have been attacked, vilified, and excluded by many people because of my bizarre way of communicating. Even my name brings a smirk to people's faces. I have caricatured one such individual in this painting.

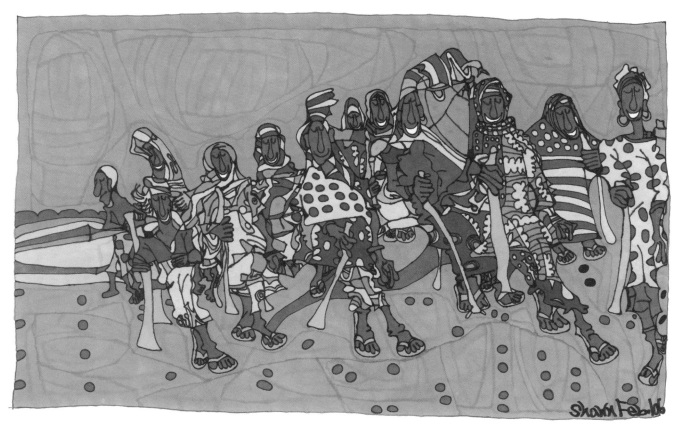

SHAWN BELANGER: WALKING STICKS; INK AND MARKERS; 17½ X 11½ INCHES; 2006.

**What was the inspiration for this piece? [answered by mother]**
*Walking Sticks* is definitely Shawn's signature piece; it appears to be the one that attracts people to his work. Many people have commented on the happiness on the women's faces and the bright colors.

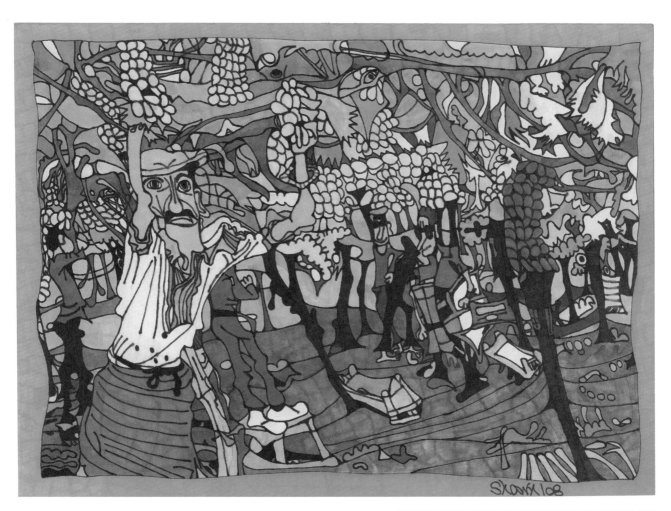

**What was the inspiration for this piece? [answered by mother]**
*The Vineyard* was inspired by a very small photo from *National Geographic*, which Shawn chose.

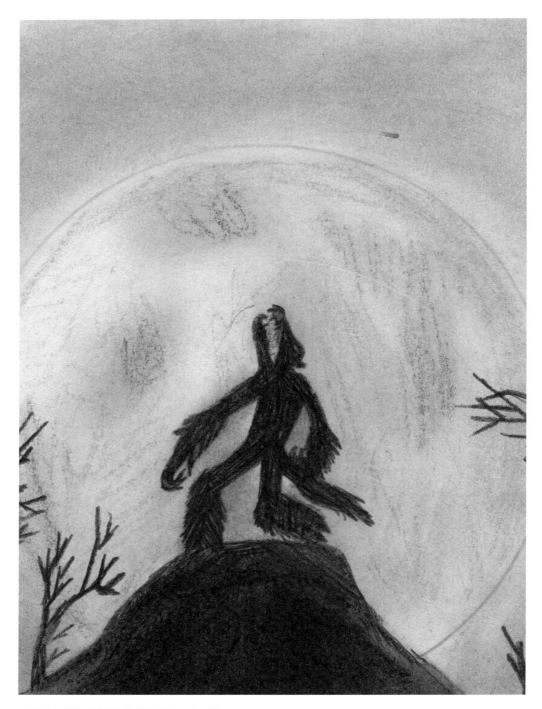

WOUT DEVOLDER: WEREWOLF; COLORED PENCIL AND PASTEL; 11½ X 8¼ INCHES; 2008 (AT AGE 14).

**What was the inspiration for this piece?**
On May 8, 2008, my nephew Ben and my niece Sanne died in a fire. I was very sad and desperate. Because I didn't have words to express my despair, I drew this werewolf. I dedicate my drawing to Ben and Sanne.

SUSAN BROWN: FAMILY; MIXED MEDIA ON CARDBOARD. COURTESY OF PURE VISION ARTS.

**At what age did the act of creating art enter your life? [answered by Pure Vision Arts]**
Brown first painted her characteristic grid-like drawings on cardboard in the 1980s while working as a dishwasher at Friendly's where cardboard packing was readily available.

**[Rohan Sonalkar passed away in 2007. His father has provided insight into his art and his life.]**

Rohan was born in 1971 and spent his infant years in the Himalayan village of Tezpur in India. Nearing the age of four years old he entered a mainstream school in Pune in western India. Within a few years, he was noticeably different. His grades dropped drastically while his agility, his short attention span, and hyperactivity enhanced. Always perched six feet above ground and fast becoming monosyllabic, he was insecure in a new place. Yet his curiosity often rocketed him toward a locomotive or aircraft.

He disliked instructions and preferred to fix his cycle, assemble Meccano sets or jigsaw puzzles all by himself. The epileptic fits that accompanied him everywhere limited Rohan to a constantly watched-over routine and medication.

ROHAN SONALKAR: LAMAS; ACRYLIC; 3 X 3 FEET; 1998.

ROHAN SONALKAR: FACES; ACRYLIC; 3 X 3 FEET; 1996.

# REPETITION, REPETITION, REPETITION

## CHAPTER TWO

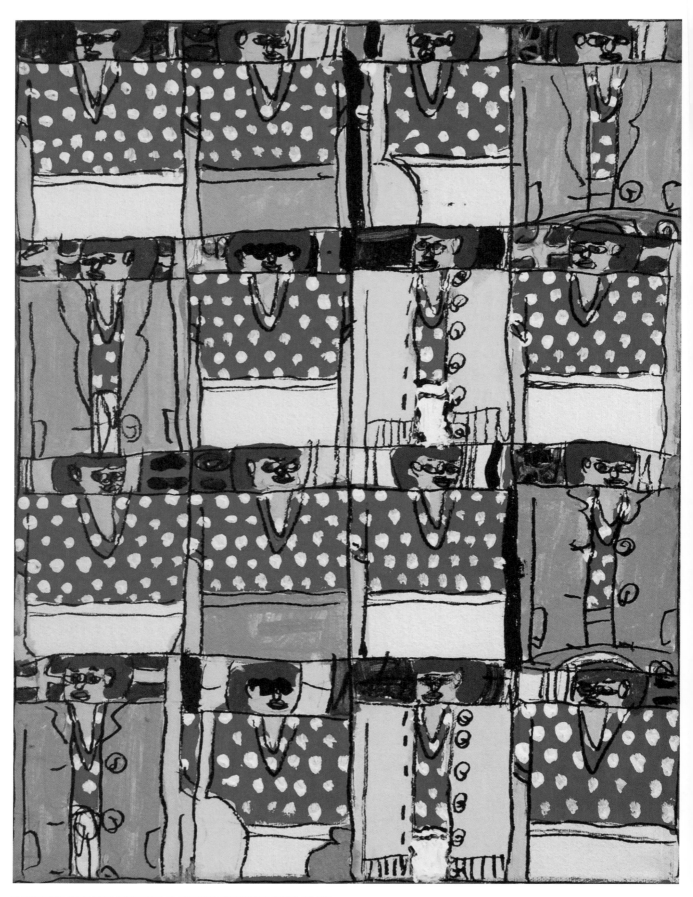

SUSAN BROWN: HER MOTHER; MIXED MEDIA ON CARDBOARD. COURTESY OF PURE VISION ARTS.

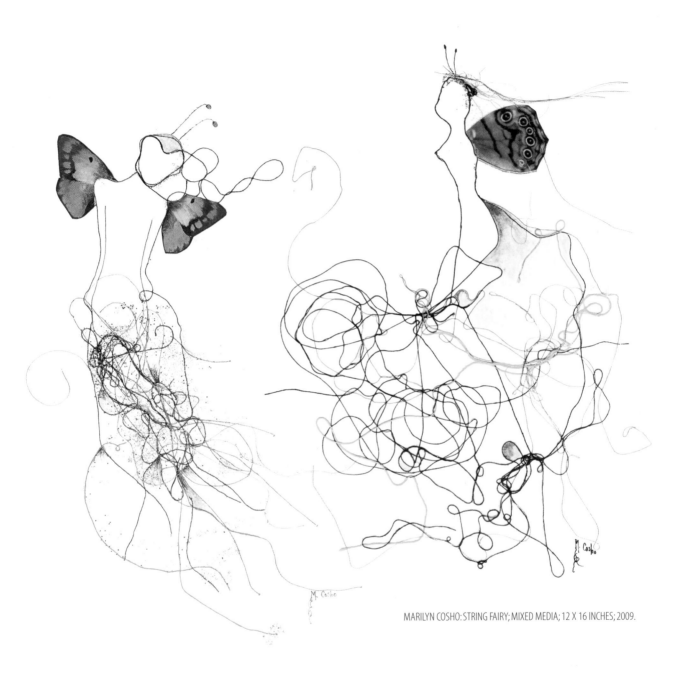

MARILYN COSHO: STRING FAIRY; MIXED MEDIA; 12 X 16 INCHES; 2009.

**What was the inspiration for these pieces?**

I have always been interested in miniatures and the world of make-believe. Creating "string fairies" combines my fascination with beauty, fragility, and detail. Fairies are not quite of this world, which I also relate to.

**What inspires/excites you about creating art?**

My art falls into two categories; a necessity, which releases built-up emotions and a more playful pastime type, i.e. my "string fairies." With the first, I am seeking honesty; the second beauty/order. Truth is very important to me. The repetitive movement in creating art is calming. My layout and design often reflect the autistic mind—being drawn to detail and order. Creating order counteracts feeling fragmented. Revealing my art to others has also been affirming. It has given me insights, inspiration, and new opportunities.

NOAH ERENBERG: STRANGE HORSES; INK, PENCIL, AND BEADS; 7½ X 5½ INCHES; 2008.

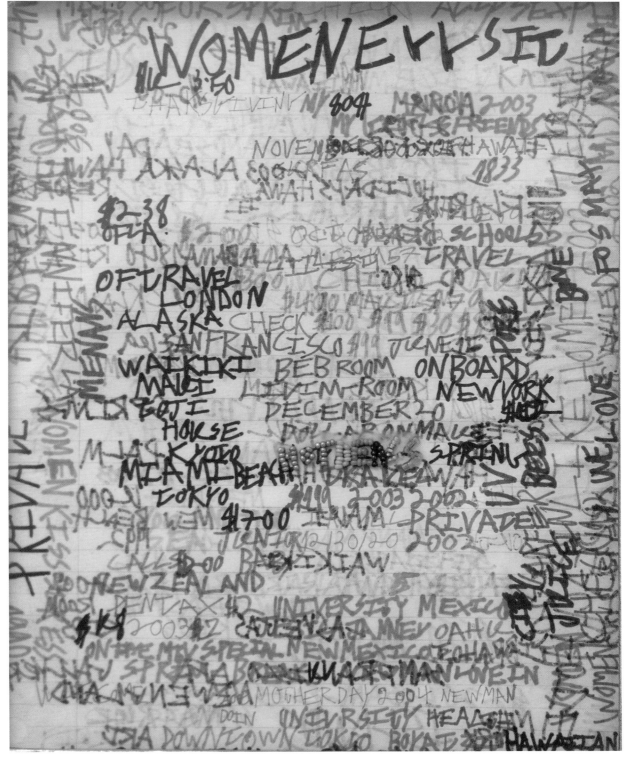

NOAH ERENBERG: HOT DEALS; INK AND BEADS; 9½ X 7½ INCHES; 2008.

**What was the inspiration for these pieces?**

I am inspired by words and symbols. I make abstract paintings and drawings because I like bright colors and shapes. Abstract painting reminds me of hip-hop music. The abstract shapes come out of my head. Abstract means "from my head."

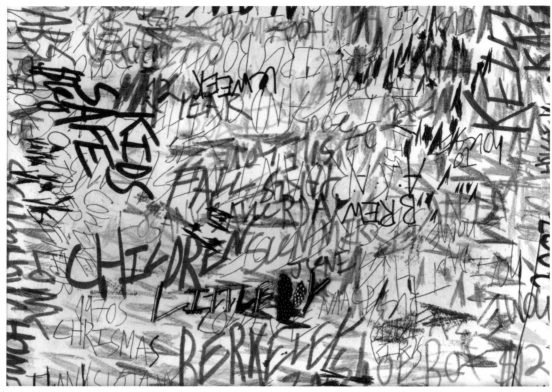

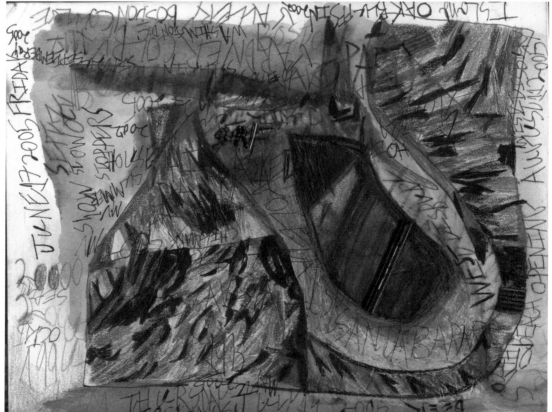

NOAH ERENBERG: (TOP) LITTLE BOY; INK AND CRAYON; 11 X 14 INCHES; 2008. (BOTTOM) BEER; MIXED MEDIA ON PAPER; 8 X 10 INCHES; 2007.

OPPOSITE: NOAH ERENBERG: BEACH; INK AND CRAYON; 15 X 12½ INCHES; 2008.

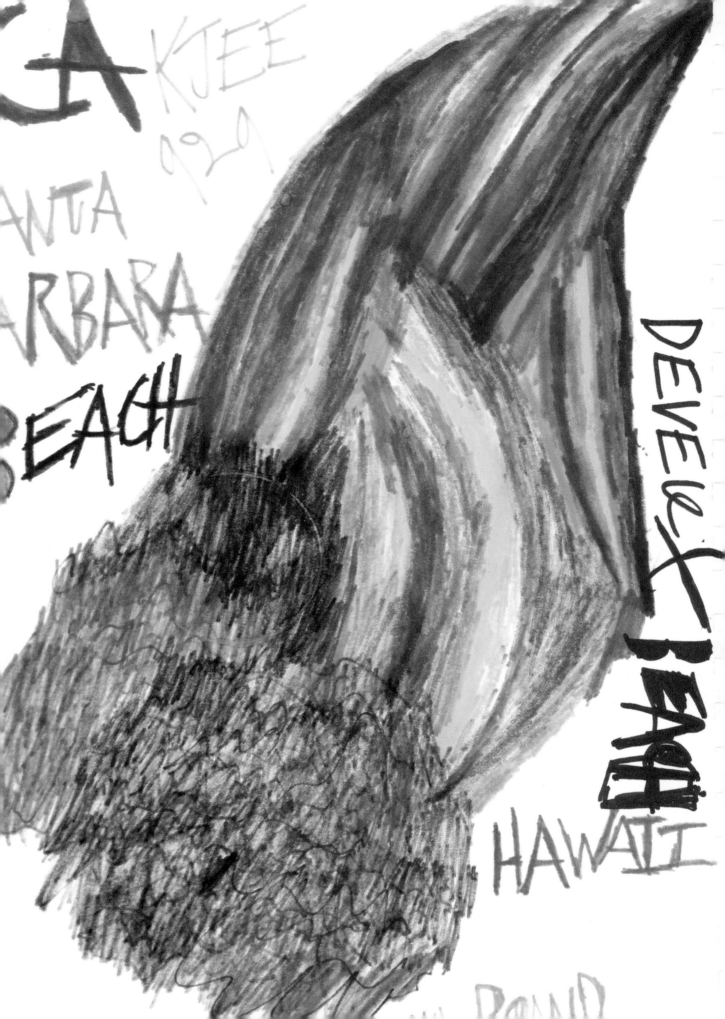

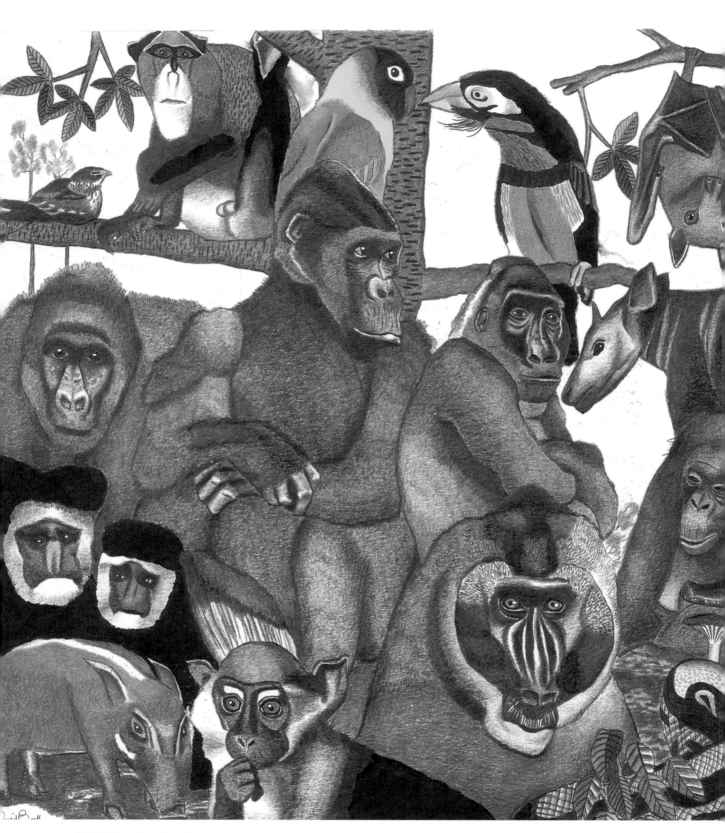

DAVID BARTH: APES; INK ON PAPER; 16½ X 11¼ INCHES; 2013.

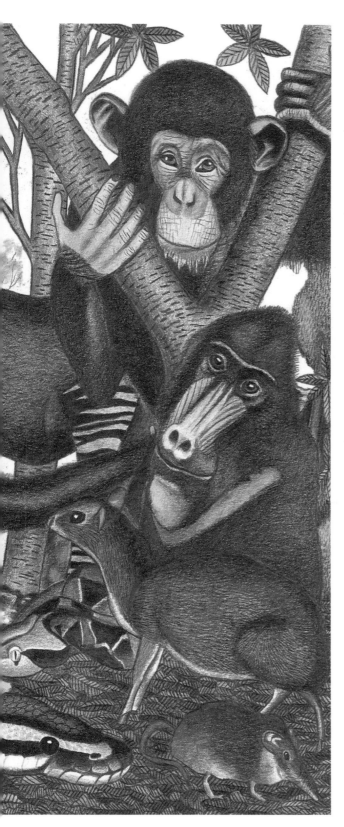

**What was the inspiration for this piece?**
I watched the Planet Earth episode about jungles and that inspired me. Many people don't know the difference between monkeys and primates. I really study all the differences and like to draw both monkeys and primates.

SHAWN BELANGER: GRANDPA'S GARDEN; MARKER AND INK; 20 X 13 INCHES; 2006.

SHAWN BELANGER: HARVEST TIME; MARKER AND INK; 20 X 14 INCHES; 2007.

**What was the inspiration for these pieces? [answered by mother]**
Shawn seems to have a liking for outdoor pictures that have trees or gardens.

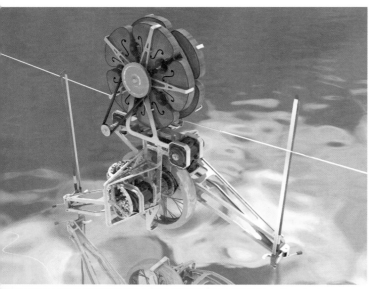
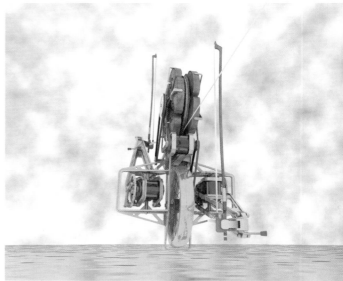
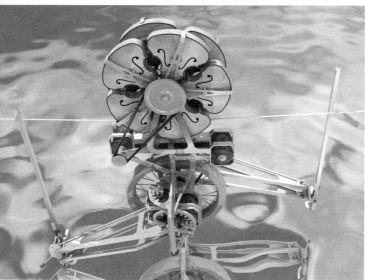
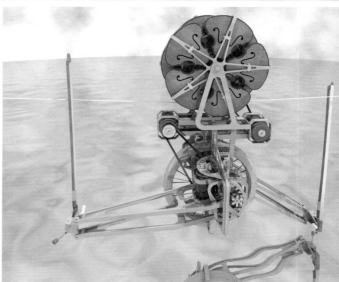

STEPHEN MALLON: TIGHTROPE FIDDLER; RENDERED VIEWS OF A 3-D COMPUTER MODEL.
TIGHTROPE FIDDLER IS PART OF A SERIES OF MACHINES DESIGNED FOR THE PURPOSE OF MAKING MUSIC.

**How do you choose your subjects? Why do you paint/draw what you do?**
Most of my concepts come from dreams, either while sleeping or daydreaming. Only a small fraction of the dream concepts that come to me ever find expression in visual or musical form. Some concepts recur and give me no peace until I have found some way to express them, even if the expression doesn't happen until years later. Concepts are usually freshest early in the morning, but the demands of the day usually crowd them out. Those concepts that can endure until an evening when I am free to work are usually the ones that find expression.

**Anything else that you'd like to say about your work?**
A lightweight grooved metal wheel rides along a taut string. The grooved wheel has ten viol bodies attached, five on each side. Bows positioned fore and aft of the viol body wheel stroke the tensioned string to produce vibrations transmitted by the grooved wheel into the resonant viol bodies. Each of the two bows is attached to the end of a bow arm pivoting on two axes, and driven by a pair of DC motors with rack-and-pinion drives. One motor moves the bow arm up and down, determining the speed of the bow stroke. The other motor moves the bow in and out, determining attack, release, and force applied to the string during the stroke. The clamp that attaches the bow to the end of the arm is also equipped with a rubber pizzicato finger. A variable speed flywheel below the string maintains stability during bow arm actions and movements of the viol body wheel along the string. Variations in roll or yaw due to torque from bow arm acceleration are stabilized by gyroscopic action. Variations in fore/aft pitch are stabilized by accelerating or decelerating the flywheel as needed to oppose torque from acceleration of the viol body wheel as it moves in either direction along the string. The flywheel and viol body wheel are belt driven by a pair of DC motors balanced fore and aft just below the string. A single tightrope fiddler could not plausibly move fast enough along a string to play a succession of notes unless separated by large intervals. To play most songs, it would be necessary to have multiple tightrope fiddlers on parallel strings.

Varying sizes of viol body wheels could be designated for higher and lower notes, like bells in a bell choir. String lengths and weights would also vary accordingly, with cellos riding on longer heavier strings than violins. Because of inertia, cello-sized viol body wheels would move more slowly and require more positioning time between notes. Violin-sized viol body wheels would be more agile. Vibrato could be achieved by adding adjustable eccentric counterweights to the flywheel, causing the entire assembly to bounce slightly on the string, increasing and decreasing string tension. Counterweights can be moved in or out of balance to control the level of vibrato.

If the apparatus is to be electrically powered, a grounding chain could be added to the bottom of the frame to dangle into the water below. The string would be made of a conducting material (such as steel) and would be energized with power voltage carrying an FM control signal to an onboard decoder. Motor action would respond to a remote centralized control system. Water sounds become apparent after the tightrope fiddler has been in action for a while.

Before the fiddler starts to play, the water below is still. As the fiddler moves back and forth on the string, the wakes left by the grounding chain eventually reverberate to distant sides of the pool, creating lapping sounds. In icy weather, crackling sparks are emitted at the point of contact with the energized string as the viol body wheel moves along it, adding percussive sounds to the music.

Fish are randomly swimming in the pool below. A prowling giant catfish follows a tightrope fiddler with hungry eyes. Eventually he leaps out of the water to take a bite, jarring the fiddler and momentarily lifting the grounding chain out of the water. The power current arcs through the body of the catfish, stunning him so that he henceforth watches the fiddler from a respectful distance. Eventually, the fiddle music induces other randomly swimming fish into a synchronized swimming ballet. Before the end of the song, the catfish joins in.

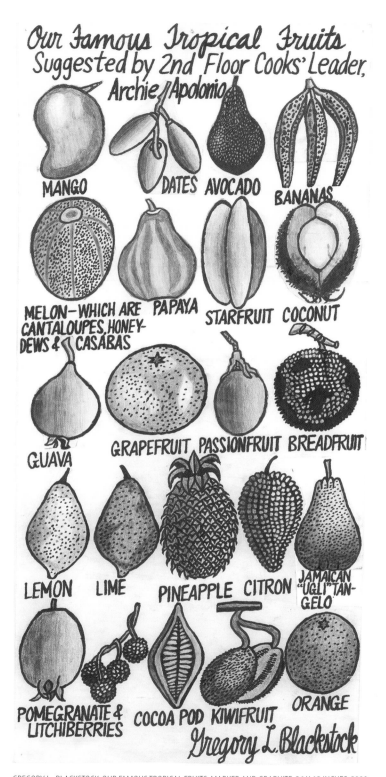

GREGORY L..BLACKSTOCK: OUR FAMOUS TROPICAL FRUITS; MARKER AND GRAPHITE; 26 X 12 INCHES; 2000.
COURTESY OF GARDE RAIL GALLERY.

**At what age did the act of creating art enter into your life?**
In 1977 I drew three of Disney's villains for fun. I was thirty-one years old.

**Why did you start creating art?**
I drew all of Disney's most famous villains in 1979 and in 1981 I drew the miscellaneous bug pests. In 1986 the Washington Athletic Club, where I worked as a dishwasher, offered to put my drawings in their employee newsletter and I started to plan out what I wanted to draw each month. They still put my drawings in there even though I am retired now.

# THE BALLS

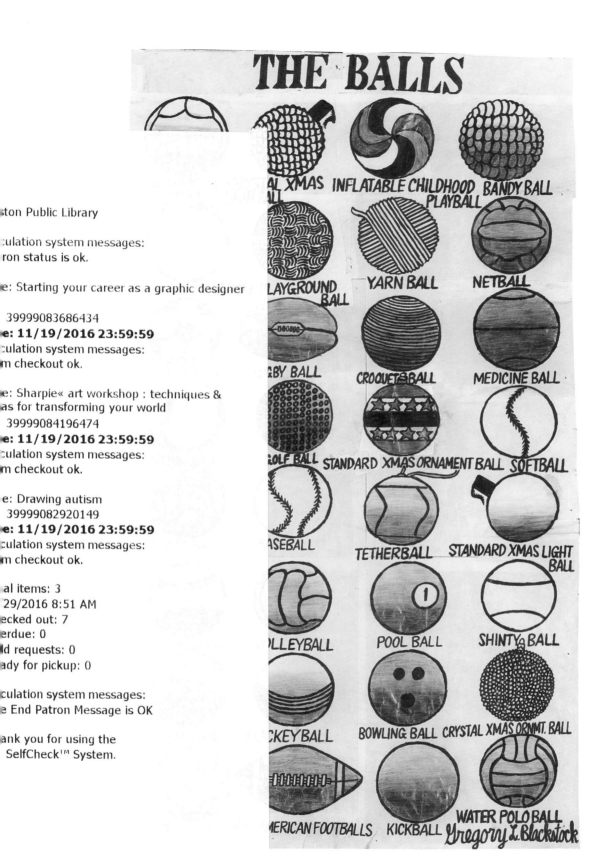

GREGORY L. BLACKSTOCK: THE BALLS; MARKER AND GRAPHITE; 30 X 16 INCHES; 1998.
COURTESY OF GARDE RAIL GALLERY.

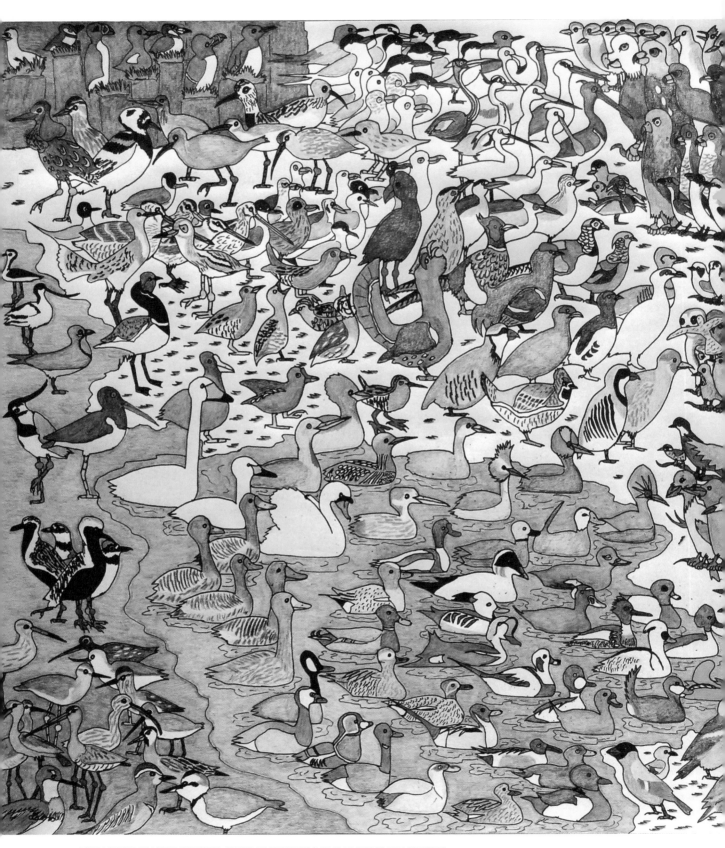

DAVID BARTH: VOGELS ("BIRDS" IN DUTCH); INK AND COLORED PENCILS; 19¾ X 25½ INCHES; 2008 (AT AGE 10).

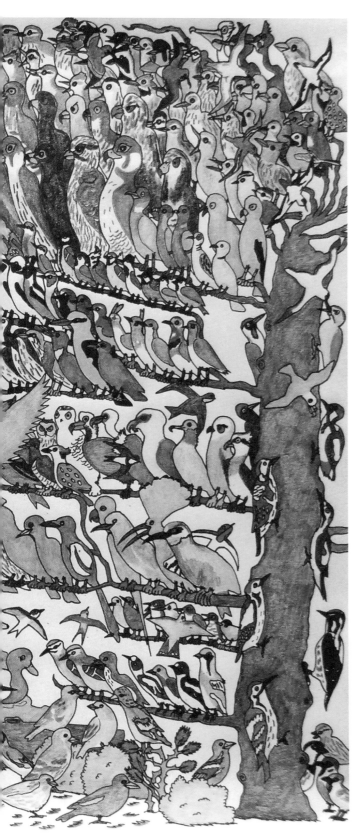

Like many autistic people, David has obsessions. His drawings often represent his current obsessions. In the attachment I sent you, it's not hard to guess what's keeping him busy right now. There are almost 400 birds on it and he knows the names and Latin names of most of them.

**What inspires/excites you about creating art? [answered by the artist]**
My obsessions inspire me. I draw various things. By drawing things, I feel more quiet in my head.

**How do you choose your subjects? Why do you paint/draw what you do?**
It depends on the things that inspire me. My obsessions depend on what I come across and can't get my mind off. By thinking about it constantly, I get restless. Drawing things that are related to my obsessions makes me quieter.

**Do you think your art helps others understand how you view the world?**
Sometimes it does. When I draw situations, people understand that the animal in my drawing is me. Sometimes, though, my drawings make the distance between me and the outside world bigger, because the objects of my fascination are not always socially accepted (vampires, war scenes, etc.).

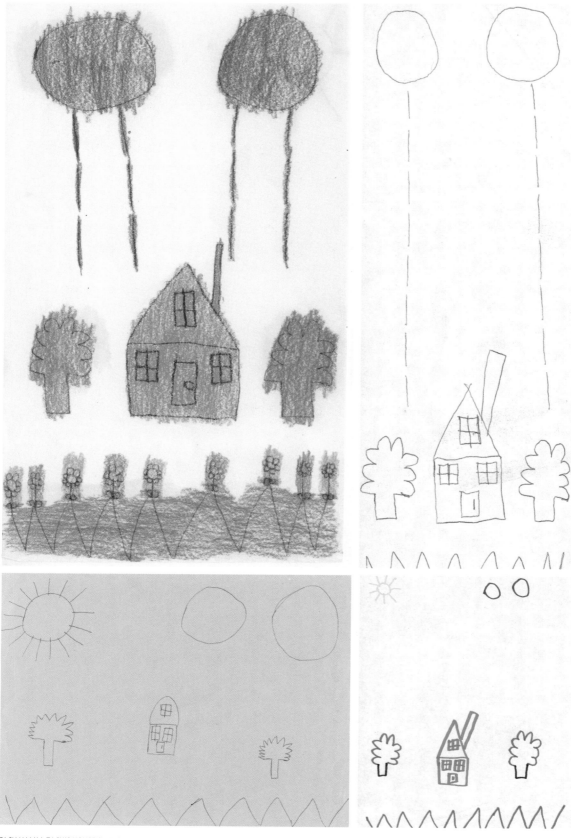

ZACH HAMM: ZACH'S HOUSE (VARIOUS)

ZACH HAMM: ZACH'S HOUSE (VARIOUS)

**What was the inspiration for these pieces? [answered by mother]**
Early in life Zach's fascinations were light poles, fans, pine twigs, curtain rod ends. He then started a fascination with spelling every word that he saw in every store. If we went to Walmart, Walmart was the word to spell with every word that lines the inside of the store. He started his artwork at the age of five. He does his art mainly with markers. There are thousands of pieces in this series, which has been created over the past seventeen years. He only replies, "My house is happy."

*Zach's House* is a house that looks like the one he lives in. It is always the same, two trees, the sun, two clouds, and grass. For years Zach has drawn this same picture. It has probably been drawn a thousand times or more.

**What inspires you about creating art? [answered by the artist]**
Because I want to. It makes me happy. I like my house. I am happy.

**How do you choose your subjects? Why do you paint/draw what you do?**
I like my house. My house is happy. It makes me happy. I am happy. All the time.

**Do you think your art helps others understand how you view the world?**
Yes. I am happy. This is what I see. My house is the same every day. It never changes. I like it too. I am happy.

**Anything else that you would like to say about your work?**
I will draw my house. I want you to see that I am happy with the way that I am. When you see me I am always the same. I don't change. My world doesn't change, it does stay the same every day. And I like it a lot. My house is always the same too. I like me. And I like my life in my house.

# GETTING FROM HERE TO THERE

## CHAPTER THREE

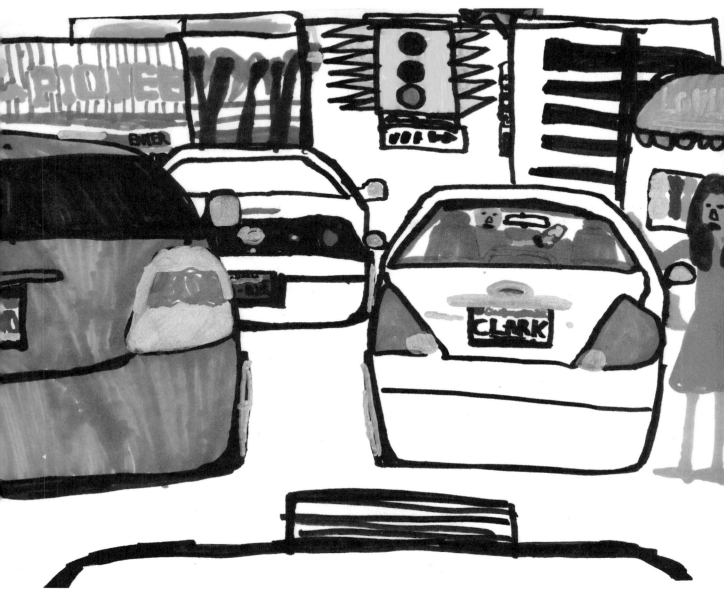

BAILEY CLARK: GIRL GETTING OUT OF CAR; MARKERS; 8½ X 11 INCHES; 2009 (AT AGE 9).

**What was the inspiration for this piece? [answered by mother]**
Bailey is trying to give his cousin some money while stuck in traffic.

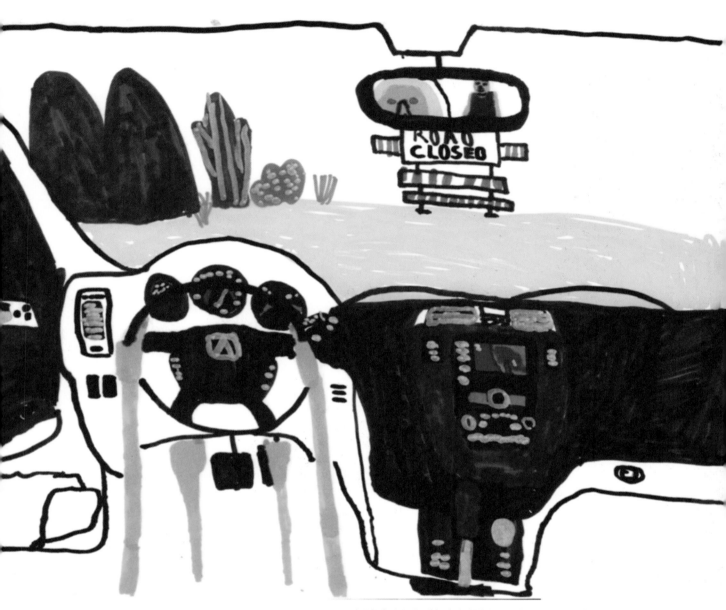

BAILEY CLARK: VIEW FROM BACK OF CAR; MARKERS; 8½ X 11 INCHES; 2008 (AT AGE 9).

**What was the inspiration for this piece?**
A girl friend from school has trouble in Mexico and the kid in the mirror helps her.

**Why did you start creating art?**
Bailey: It makes me feel good.
Mom: We have noticed that creating art calms Bailey and helps him center himself when he is concerned.

**How do you choose your subjects? Why do you paint/draw what you do?**
Mom: Bailey loves cars and all of his drawings will have at least one car in them as a central part of the picture. His art captures so much detail it helps me to see how he is flooded with information from every source but at the same time he can focus on the tiniest detail and create art.

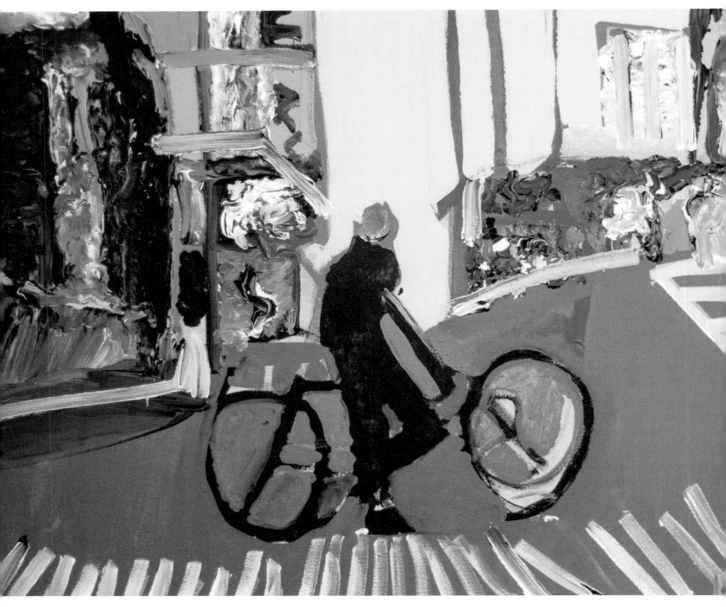

KEVIN HOSSEINI: BUS OR CYCLE; ACRYLIC; 18 X 24 INCHES; 2012.

**What inspired these pieces?**
I like to paint busy cityscapes with lots of traffic and landscapes
with cows and horses.

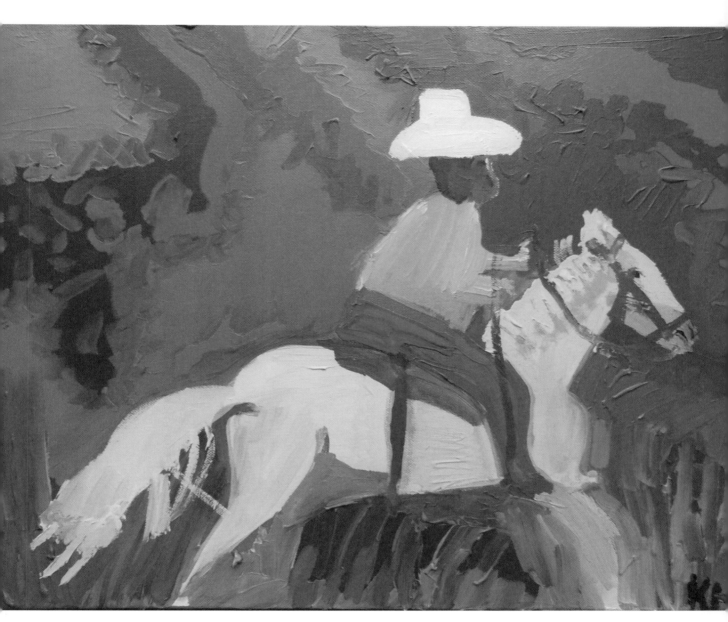

KEVIN HOSSEINI: MAN ON WHITE HORSE; ACRYLIC; 12 X 12 INCHES; 2011.

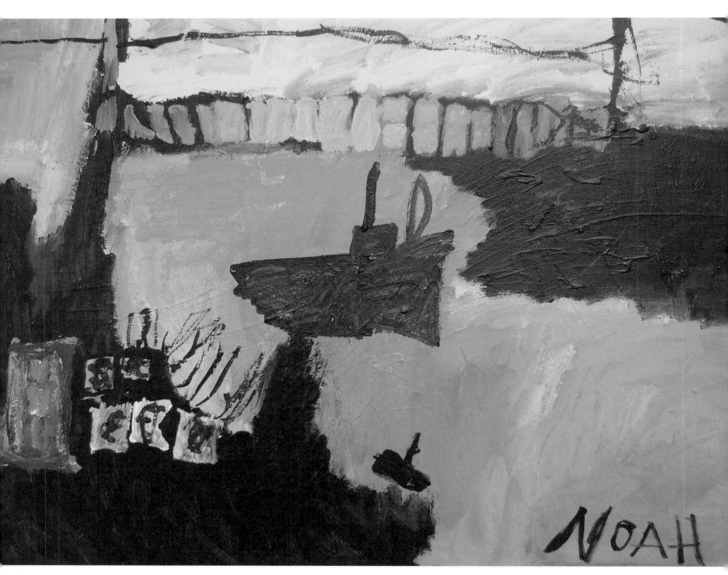

NOAH ERENBERG: SHIP; ACRYLIC ON CANVAS; 24 X 18 INCHES.

**What inspired this piece? [answered by Noah's mother]**

Noah never discusses why he paints what, so I have no clue. But he does look at images from magazines and posters and newspapers often and if something appeals to him he will paint his own version of the image. But he can never explain why he chooses what image.

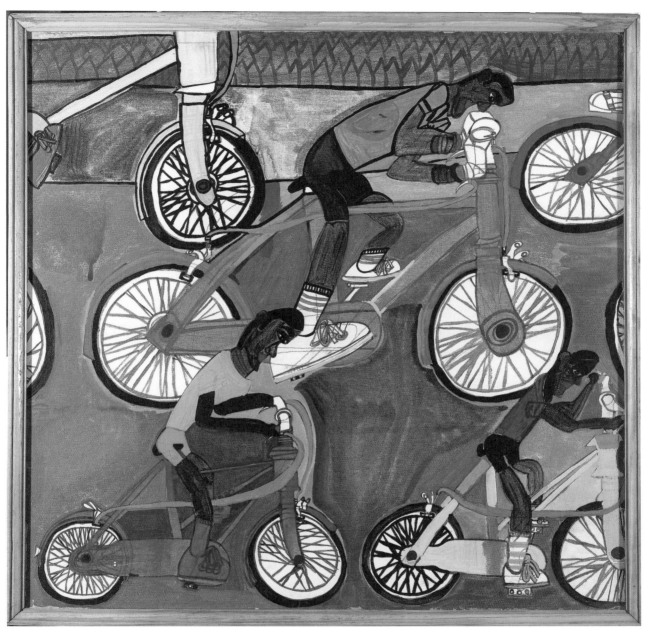

ROHAN SONALKAR: CYCLE RACE

**[From an interview with Rohan's art mentor Bal Wad at an exhibit of Rohan's work at the United Cerebral Palsy/CLASS Community Service Centre in Pittsburgh, PA]**

Rohan works in primary colors. Their proportions add value to the picture. Notice how he befriends his characters in his cartoons, willing them to do his bidding.

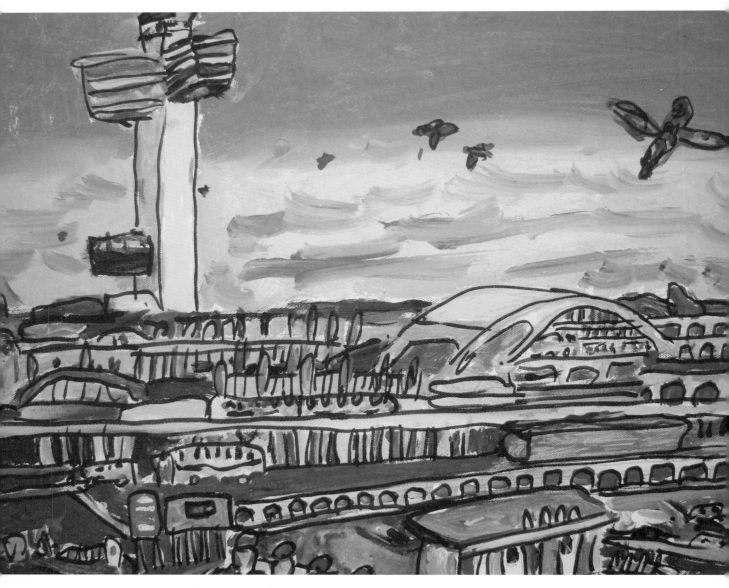

SUSAN BROWN: THE JOHN F. KENNEDY INTERNATIONAL AIRPORT; ACRYLIC AND MARKER; 20 X 24 INCHES; 2008. COURTESY OF PURE VISION ARTS.

**[From Pure Vision Arts]**
Brown's art reflects an eclectic interest in portraiture, transportation, and landscapes. Her imagery is based on actual prodigious memories and life experiences.

OPPOSITE: SUSAN BROWN: STATEN ISLAND IN THE MORNING; ACRYLIC; 20 X 24 INCHES; 2008. COURTESY OF PURE VISION ARTS.

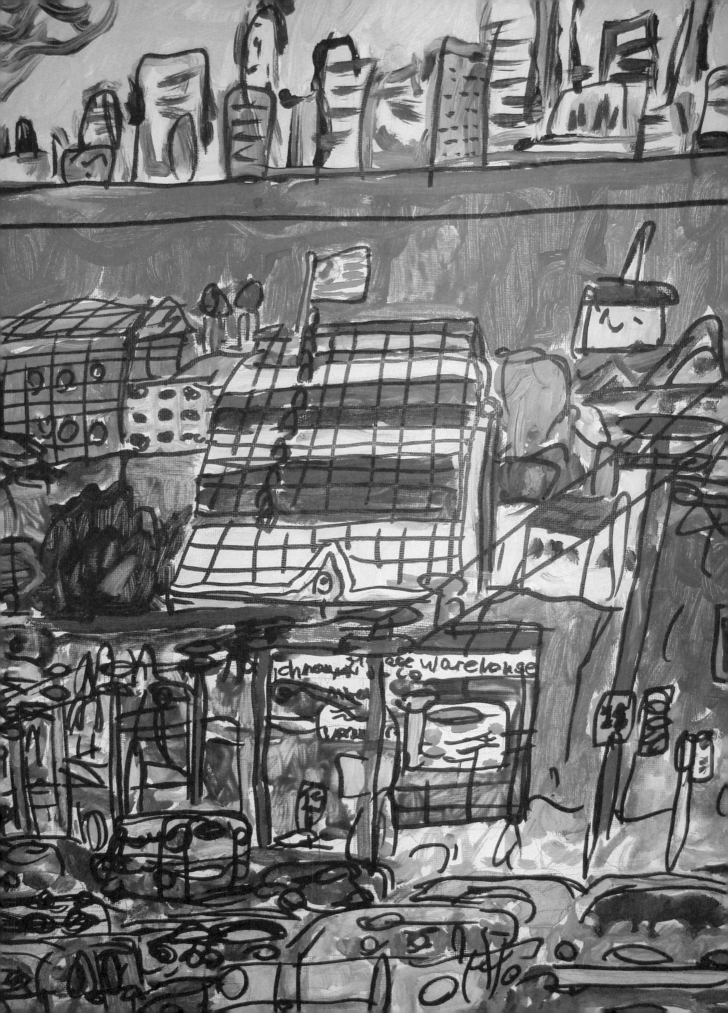

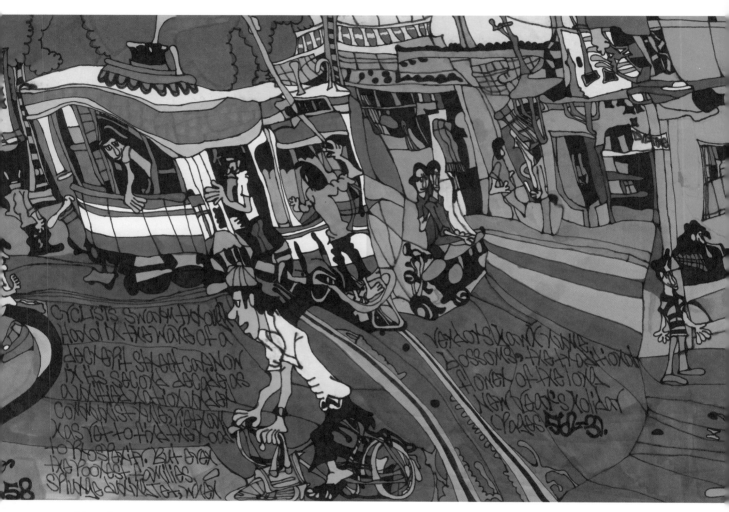

SHAWN BELANGER: STREETCAR IN HANOI; INK AND MARKER; 20 X 13 INCHES; 2006.

**What was the inspiration for this piece? [answered by mother]**

*Streetcar in Hanoi* is different than many pieces he has done. The colors in the photos are not the colors that Shawn chooses to use when he is adding color. He definitely has an opinion as to the use of color. We love the fact that when he was drawing the bike he could not fit the tire in with it being round so he just squared it off. Shawn also wrote the words on the page, something that he had never done before.

# BIRD'S-EYE VIEW

CHAPTER FOUR

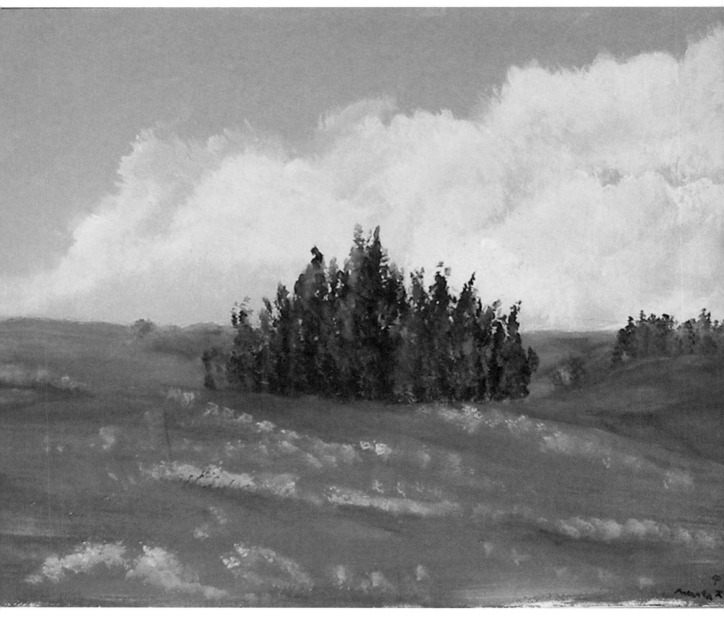

AMANDA LAMUNYON: CEDARS; 2008 (AT AGE 13).
COURTESY OF DR. ROSA C. MARTINEZ/STROKES OF GENIUS, INC.

**Why did you start creating art?**
I learned I could paint when I was seven years old. Before I could paint I would take paper and tape and make all kinds of things. My parents say that with paper and tape I could create almost anything. My parents hoped it would be a good thing for me to help me stay focused. It became more than me staying focused. It caused people to look at me differently and accept me more even though I was a little different.

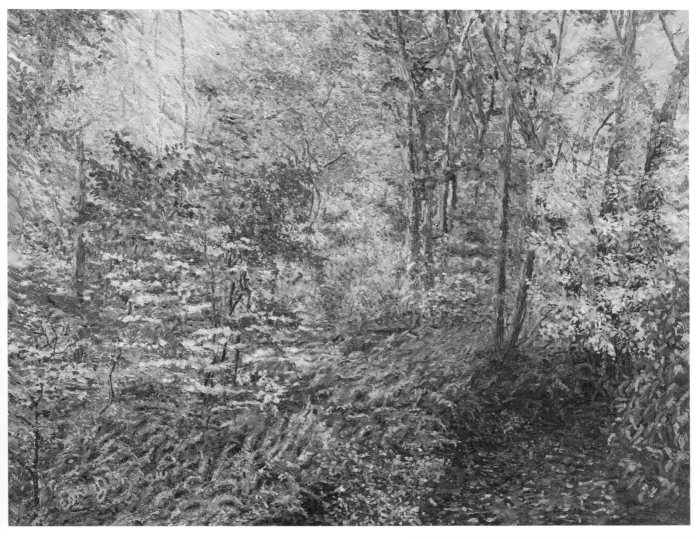

ESTHER J. BROKAW: AUTUMN IN THE WOODS; OIL ON CANVAS; 22 X 28 INCHES; 1996.

**Why did you start creating art?**

I had bare walls and a strong desire to paint but I had to do a writer's exercise to get past the fear before I could even try. Through a great mentor, I learned that I was more afraid of living my life without trying and passing that fear on to my children, than attempting to paint. I named my first painting *The Awakening* because it truly was.

**Do you think your art helps others understand how you view the world?**

My reason for going public with my savant diagnosis is to increase awareness of the talent that exists in many on the autistic spectrum and to encourage the world to utilize these talents.

**What was the inspiration for this piece?**

As a child I loved to peer into the forest with all the light streaming in through the leaves. As an adult I wanted to paint this painting in autumn in the woods, showing the light coming through the brightly colored leaves like stained glass in a cathedral. Standing in the woods I get an awe-inspiring shiver and a spiritual inspiration.

KEVIN HOSSEINI: TOKYO III; ACRYLIC; 24 X 30 INCHES; 2013.

**What inspired this piece?**
I like to roll the brush on the canvas with heavy paint. I like to spread the paint with my palette knife.

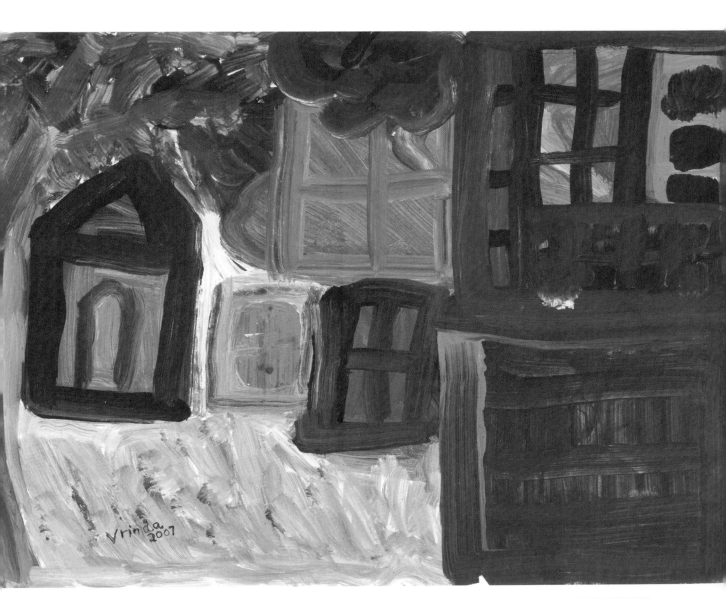

VRINDA CHASWAL: DD; 2007 (AT AGE 16). COURTESY OF ACTION FOR AUTISM, INDIA.

**What was the inspiration for this piece? [answered by mother]**

Near Vrinda's home there are apartments and a temple (the slanting roof) and she likes how these look at night because of the lights. She says the houses have lights on in the painting and there are shadows of people in one of the windows.

**Why did you start creating art?**

She has fixations—as a child she drew a variety of water tanks, then toilets. Age ten onward she got into painting water, sky, houses with doors and windows. She often asks to go inside houses that she sees.

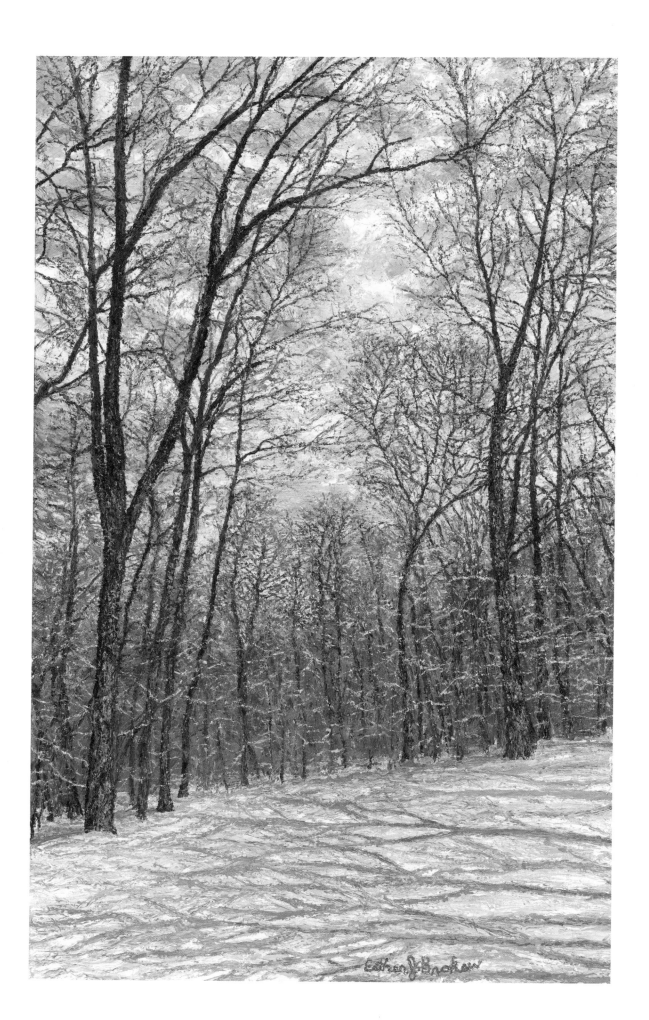

OPPOSITE: ESTHER J. BROKAW: WINTER TREES; OIL; 36 X 22 INCHES.

### What was the inspiration for this piece?
The view is from atop a hill looking down through the leafless trees. I pulled together a beautiful sky I saw one day with the shadows of the trees on the snow as well as the snow-covered branches lisping through the trees. The colors are the colors I see and I locate them next to colors that complement one another. I like to make my paintings timeless and use subjects that everyone can relate to so they are meaningful for all.

### Anything else that you'd like to say about your artwork?
With no formal training, a passion to paint led me to the discovery of a God-given talent that shows me to heal with color. Through years of children and illness, these paintings represent impressionist masterpieces from my soul.

My intense work with brushstroke and color bears a painting that can be appreciated as much close up as from a distance. I paint with symbolic composition, usually unintentionally, that leads to a deep individual interpretation.

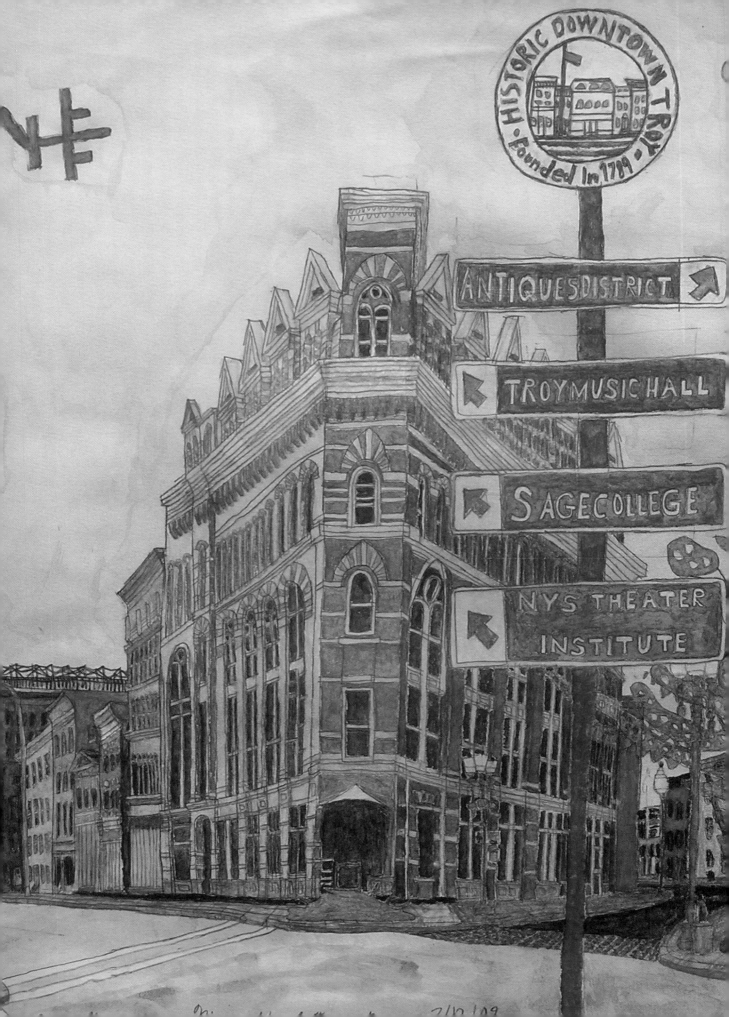

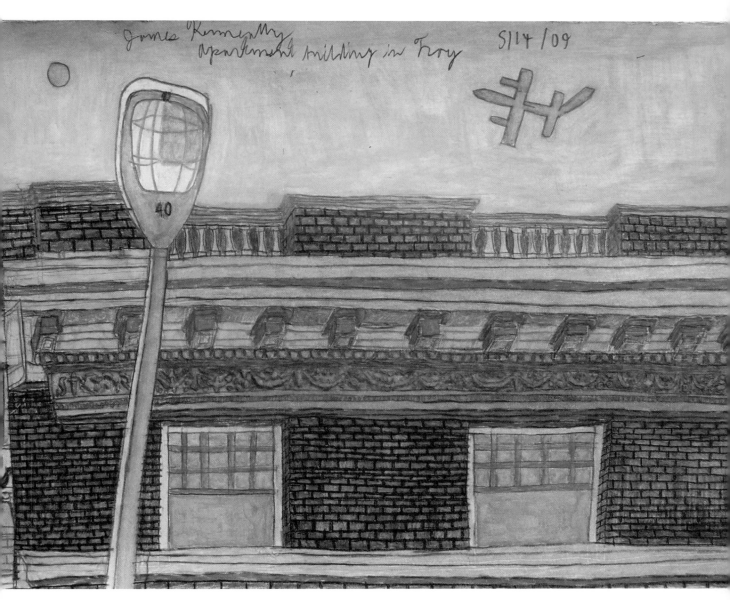

James Kenneally
Apartment building in Troy
5/14/09

JAMES KENNEALLY: APARTMENT BUILDING IN TROY; WATERCOLOR AND INK; 15 X 22 INCHES; 2009.
COURTESY OF LIVING RESOURCES CARRIAGE HOUSE ARTS CENTER, US.

OPPOSITE: JAMES KENNEALLY: RIVER STREET, TROY, NY; WATERCOLOR, PENCIL, AND INK; 22 X 17½
INCHES; 2009. COURTESY OF LIVING RESOURCES CARRIAGE HOUSE ARTS CENTER, US.

**At what age did the act of creating art enter into your life? [answered by mother]**
As a young child James liked to create landscapes of New York City on his Etch A Sketch. He chooses to draw buildings.

**How do you choose your subjects?**
Sometimes his art teachers entice him to draw other things like faces and objects, which he does very well. But his first choice would be a building. I believe he chooses to draw them since they are always in the same place and look the same each time he sees them.

**Do you think your art helps others understand how you view the world?**
James is in his late thirties, living with autism, mild mental retardation, and epilepsy. He is very autistic and has some behavioral issues. Art has allowed him to be recognized by his community for his ability, not his disability. He knows when a finished picture looks good and is very pleased with himself.

**Who are some artists that you like?**
Any painting that includes buildings is interesting to him, regardless of the artist or architect.

MICHAEL P. McMANMON: CAUGHT IN REALISM; WATERCOLOR ; 11 X 14 INCHES; 2011.

**What inspired you to start painting?**

When I was young I started to draw trees and strictly used pen and ink and pencil. I did not have the courage to break out of this and was afraid to make mistakes or try new things that I may not have been successful at. When I was diagnosed with Asperger's syndrome in my fifties, it changed my life. I realized that I did not have to try to be perfect anymore. With my art, I began to experiment with color and then painting. I decided that it did not matter if every work was perfect or complete. The same relates to my life—I decided to be open to new ideas by default, instead of the opposite. I started to see things in a new perspective and I now see the beauty that I did not previously see. I decided that I can experience the world in any way that I want.

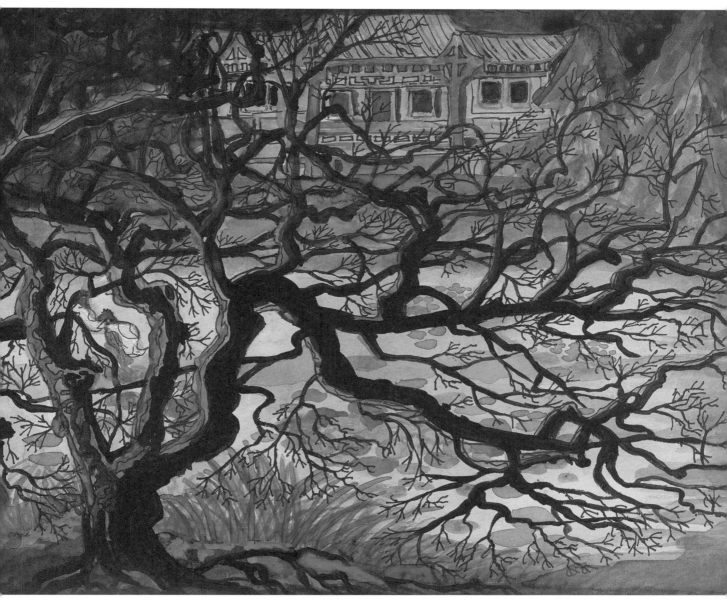

MICHAEL P. McMANMON: JAPANESE GARDEN; WATERCOLOR; 11 X 14 INCHES; 2012.

**What inspired this piece?**
A lifelong obsession of trees and the curves and balance of the branches inspired the painting. Painted in Sydney, Australia.

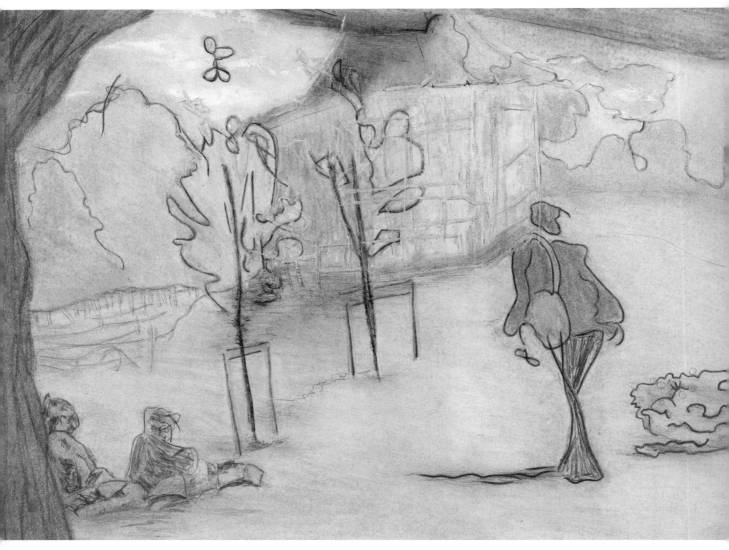

KAY AITCH: WESTON PARK; MIXED MEDIA DRAWING.

**What was the inspiration for this piece?**
This is somewhere I walk through several times a week. On this occasion I was early going somewhere so I sat down to draw awhile. I was interested in the blue of the bandstand, which was newly renovated. I also like to sketch people quickly as they walk past—drawing without looking at the paper is useful for this as I can concentrate on seeing as much as possible in a short time. The finished drawing is in wax crayon with some paint and highlighter pen.

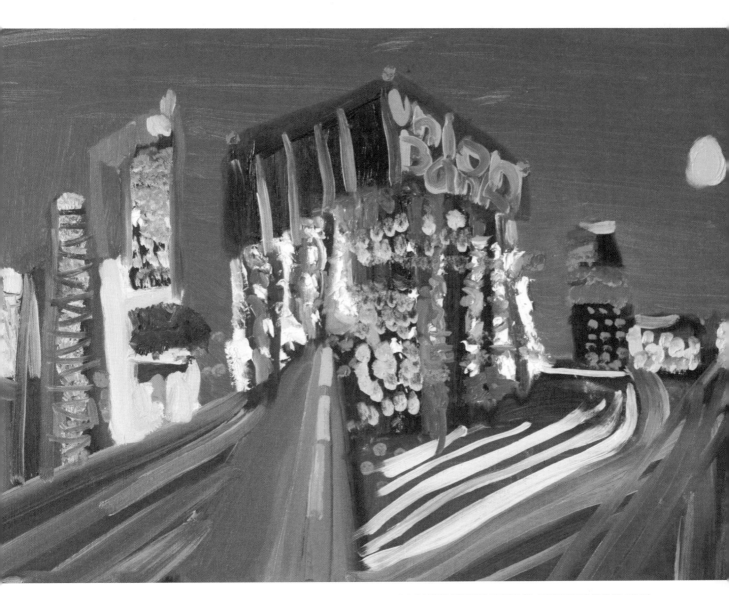

KEVIN HOSSEINI: NEW YORK AT NIGHT; OIL; 18 X 24 INCHES; 2009 (AT AGE 15).

**Is there anything you would like to say about your work?**
My artwork is easy for me to do. I like to mix colors.

ELENI MICHAEL: PICTURE #007.

**What was the inspiration for this piece?**
I wanted to create a mysterious, beautiful image of nature. This painting is about my yearning for beauty and harmony in the world. (As a keen gardener I express the same desire in that pursuit.) The painting also depicts the relationship between flora and fauna; the natural chain, every link, depends on the other.

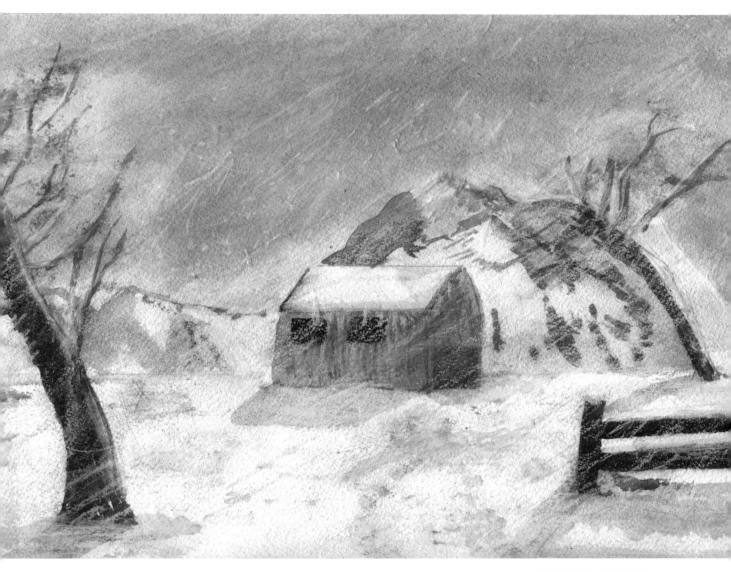

**What was the inspiration for this piece?**
This was actually a school project where we had to draw what
we thought would be appropriate for a wintery scene.

**At what age did the act of creating art enter into your life?**
Because of my autism I would never draw when I was younger.
When I was twelve years old there was a school project where
we had to draw our favorite animal. I drew my pet macaw,
Tiny. When my teachers saw my drawing they called my parents
because they had never seen any twelve-year-old draw like I did.

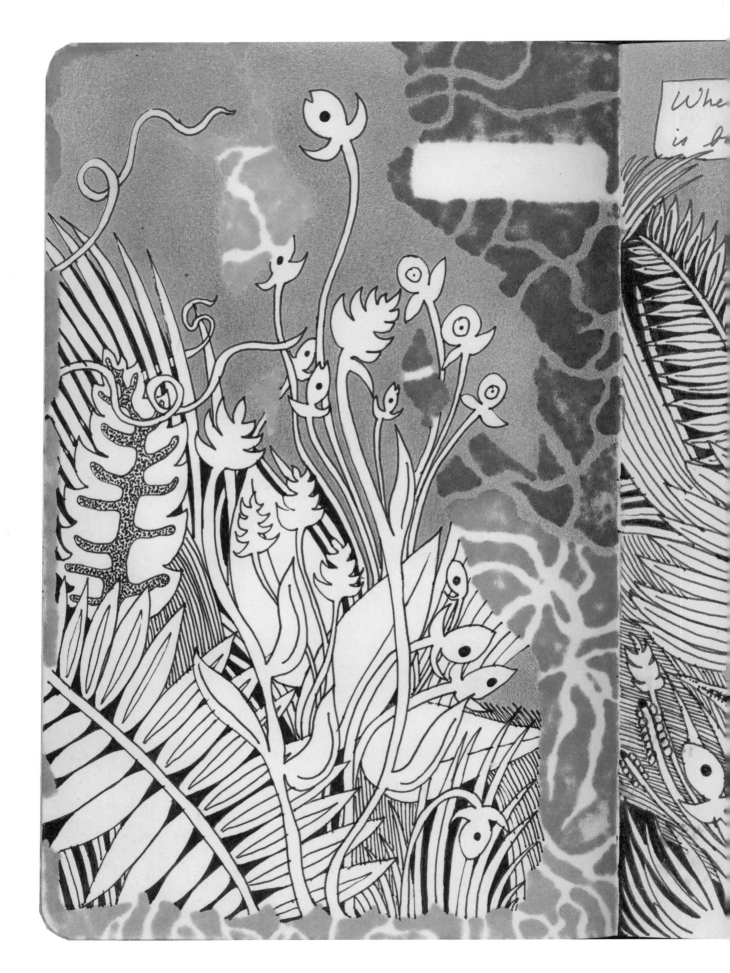

When
is b

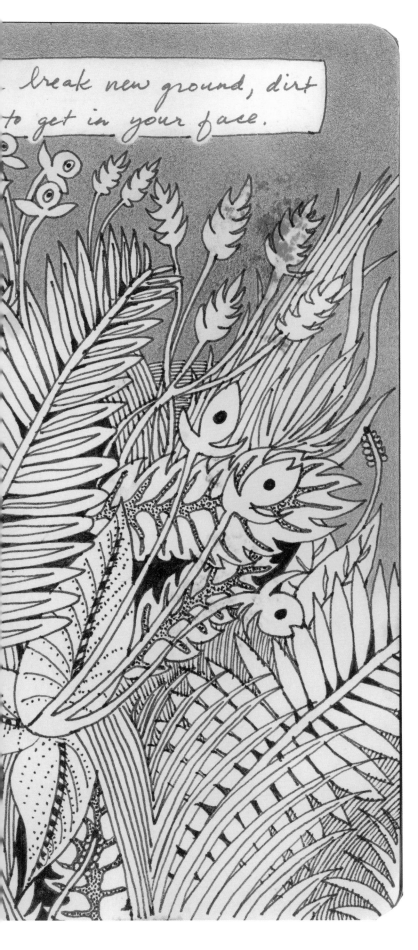

break new ground, dirt to get in your face.

**What inspried this piece?**

It doesn't really have any symbolic inspiration. Just a doodle. It's design guided by permanent marker that had bled through from the page previous in the sketchbook.

EMILY L. WILLIAMS: JUNGLE; GRAPHITE AND INK; 10 X 8 INCHES; 2008.

ROHAN SONALKAR: SKYLINE; ACRYLIC; 3 X 3 FEET; 1995.

**[Written by father]**

Observing without seeing: If you pointed out something to Rohan he would not turn to see it. Watching him cross a busy street, one would panic at his lack of focus on the traffic. In the car, he was more absorbed in a video game than the route. But his ability to recount the details of where he had been, even when it didn't seem like he was paying attention, was astonishing. Within a fraction of a second Rohan could reach into the events as far back as when he was three—picturing it complete, even including the sounds of that moment.

VEDHAS RANGAN: A; COURTESY OF THE ACADEMY FOR SEVERE HANDICAPS AND AUTISM IN INDIA.

**[Written by the director of the Academy for Severe Handicaps and Autism in India]**

Vedhas is very meticulous and thorough in his work. He is well organized and takes care of himself. He is a good artist and eager to learn new activities. Vedhas avoids new people and new environments.

# ANOTHER WORLD

CHAPTER FIVE

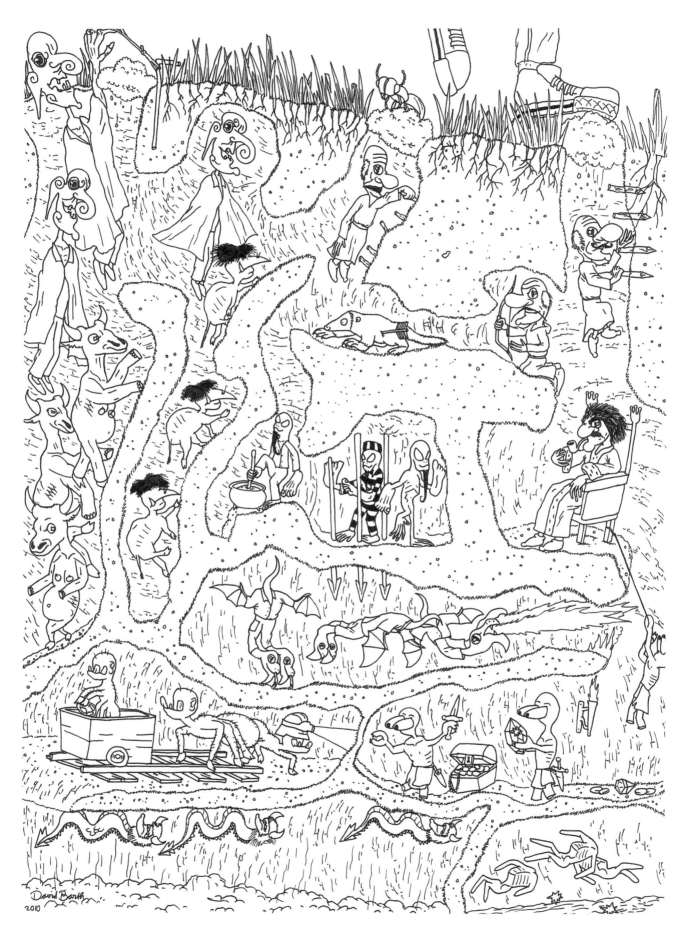

DAVID BARTH: UNDERGROUND; INK ON PAPER; 16½ X 11¼ INCHES; 2012.

**What inspired this piece?**

I like to draw nonexistent creatures every now and then. It's limit-less and that's fun. It doesn't have to be realistic or functional. That gives me the freedom to use my imagination.

ALEXANDRA HILL: PARTY WITH UNICORN; PEN AND WATERCOLOR; 20 X 20 INCHES; 2008.
COURTESY OF TUTTI VISUAL ARTS AND DESIGN PROGRAM IN AUSTRALIA.

ALEXANDRA HILL: CHANGELING; GRAPHITE AND ACRYLIC; 16 X 16 INCHES; 2006.
COURTESY OF TUTTI VISUAL ARTS AND DESIGN PROGRAM IN AUSTRALIA.

**How do you choose your subjects?**
I don't know why, it is just like another world.

**Why did you start creating art?**
Because it is fun and I use my imagination.

**Anything else you'd like to say about your work?**
These illustrations are from my "Fairy Book."

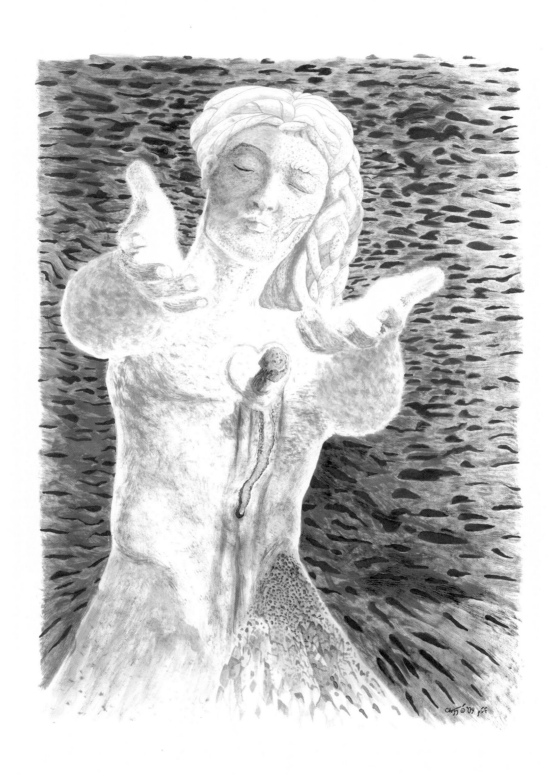

CHARLES D. TOPPING: THE DEATH OF LOVE #373: DESICCATED LOVE; WATERCOLOR; 14 X 10 INCHES; 2009.

**The following text has been extracted from an e-mail exchange between Jill Mullin and Charles D. Topping, regarding the title of this piece. (Created for *Drawing Autism*, this is Topping's first time using watercolors.)**

**SUBJECT: #37, QUANTUM NUMBERS, AND CHUCK HASN'T SLEPT IN WAAAAY TOO LONG . . .**

Hi Chuck,

Thanks for getting back to me. I did receive the CD. I received the "The Death of Love #37" and I cannot believe the artist you admire just named a piece the same name! What a small world, you are right, there must be something in the cosmos. I will talk to the editor and if there is a copyright issue, what would you like to change the name or number to?

---

I used www.random.org to generate a true random number and was given #373. That works for me, if it is okay with you. :) Weird how it is similar to #37. Perhaps we should play 37 as the Powerball number in the lottery, eh? :) If #373 is too goofy, or too similar to Tara McPherson's title, I will accept any number you wish to use. I am fine with any number really—no need to sweat the small stuff.

However, here are some number facts for those with no life:

37 is the only two-digit number in base 10 whose product, when multiplied by two, subtracted by one, and then read backwards, equals the original two-digit number: 37x2=74-1=73, 73 backwards is 37.

373's claim to fame is that it is itself a prime number, while also the sum of five consecutive primes (67 + 71 + 73 + 79 + 83).

That was from "past-life Chuck." I no longer sit around playing with numbers in my head. I swear. Lucky you! :)

#53 ("ng saam" in Cantonese) sounds like "m sang (唔生)"—"not live," and so is associated with "death" in Cantonese. Perhaps that would be an appropriate number.

Don't use any number with the #4 in it if your book's market will include Chinese, Vietnamese, Japanese, or Korean cultures: it is considered an extremely unlucky number. They skip numbering floors of buildings with any #4 in it (as we do with 13th floors), and don't start any cell phone number with the #4. (Then again, #42 is "the meaning of life, the universe, and everything.")

Okay—this has just officially entered the absurdly insane zone. :) Never mind! Bedtime for me!

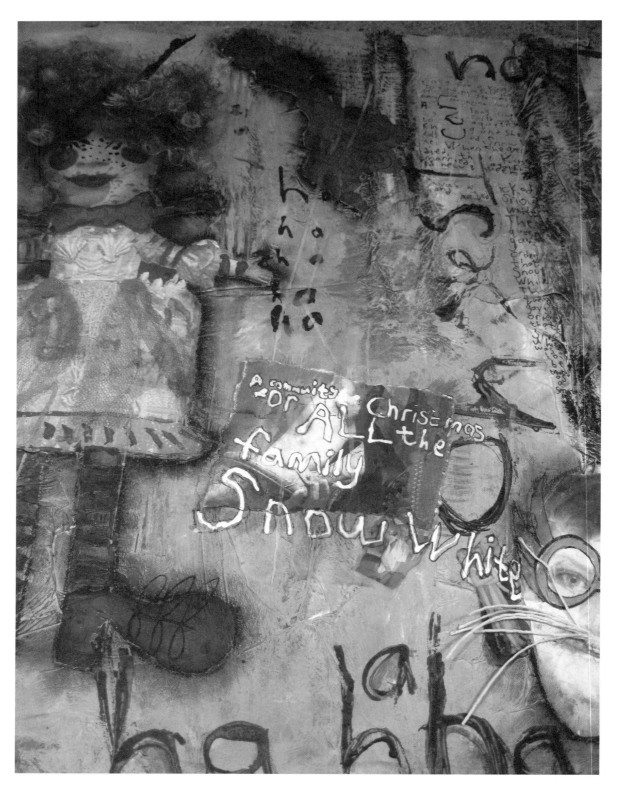

DANIEL POUT: A COMMUNITY OF CHRISTINAS.

**What was the inspiration for this piece?**
This image was based on the theme of memory and we looked
at an artist called Teesha Moore who produces fun work with lots
of different materials.

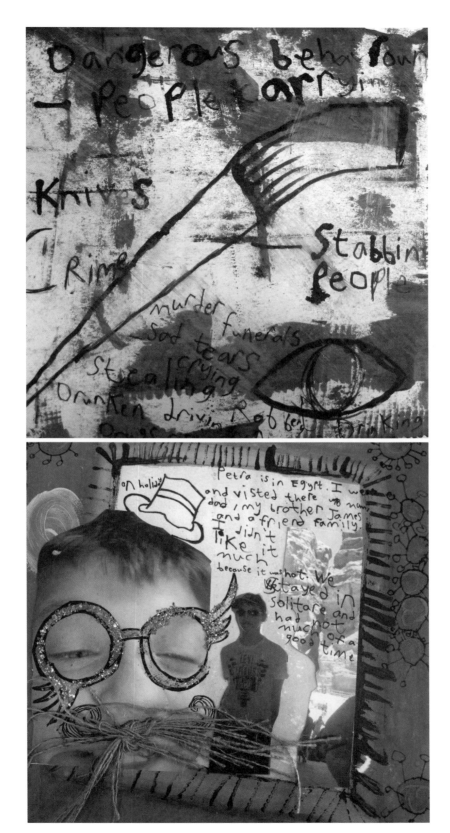

DANIEL POUT: (TOP) DANGEROUS BEHAVIOR; (BOTTOM) COLLAGE #1.

**What inspires/excites you about creating art?**
I can make interesting images, mixing up the world.

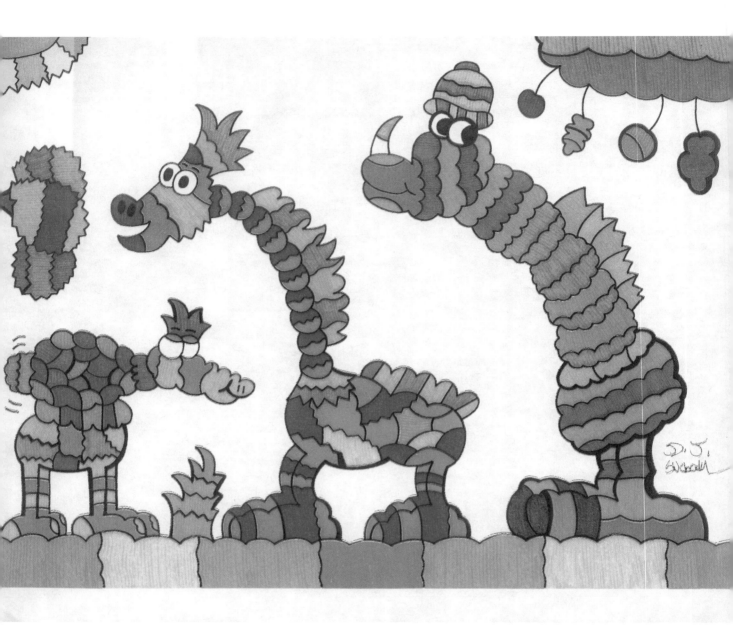

D.J. SVOBODA: BIG FIELD FRIENDS; MARKER.

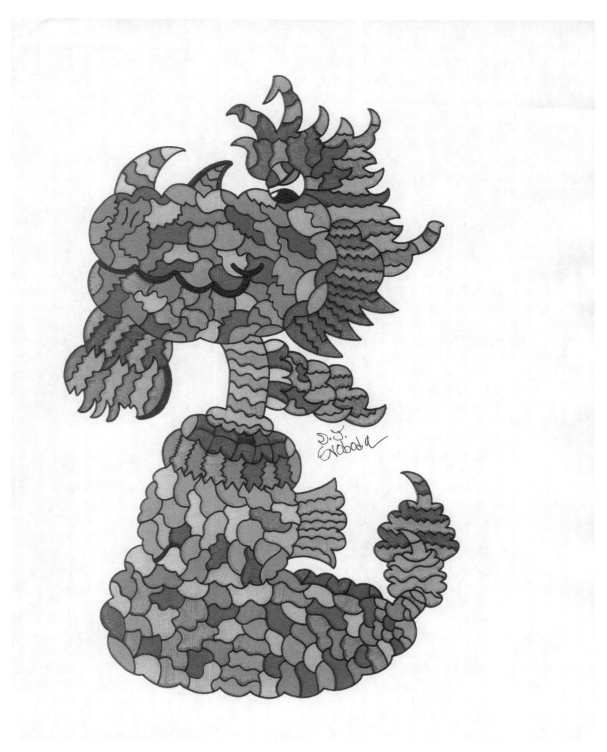

D.J. SVOBODA: SNEAKY VEGALOKOTOV; MARKER.

**Why did you start creating art?**
I started doing art because I want to bring hope and confidence
and joy and encouragement to all those with autism and disabili-
ties, and everyone across the world.

**How do you choose your subjects?**
I always think of each Imagifriend and I write a name and story
about each one. It all comes from my imagination.

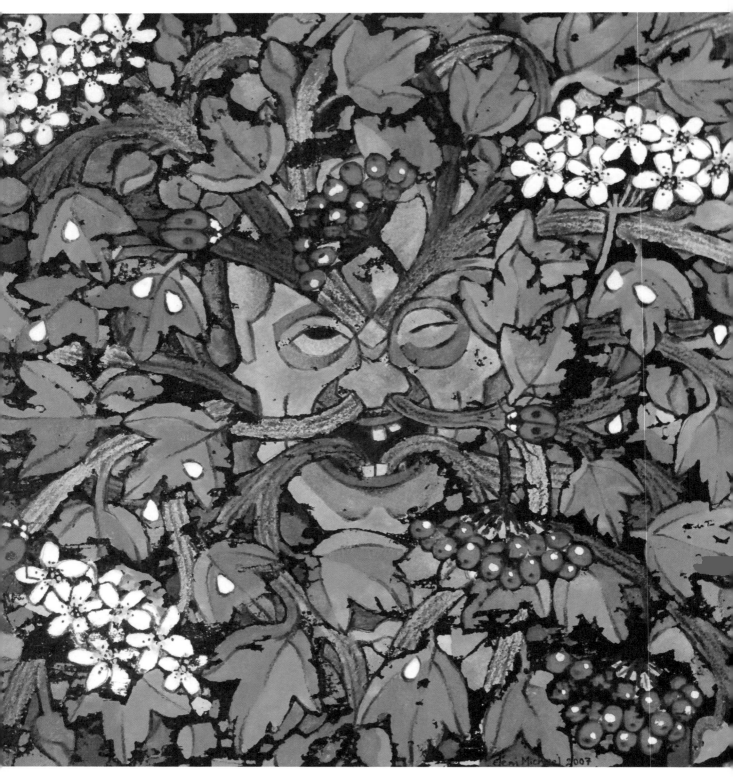

ELENI MICHAEL: THE GREEN MAN; GOUACHE AND INDIA INK; 11¾ X 11¾ INCHES; 2007.

**What was the inspiration for this piece?**
The Green Man myth fascinates me and I have done a few paintings on this theme. I love the natural world and often paint nature subjects. This one is meant to convey both the beauty and the brutality of life. It interests me that a Green Man story exists in so many diverse cultures and is therefore a universal theme.

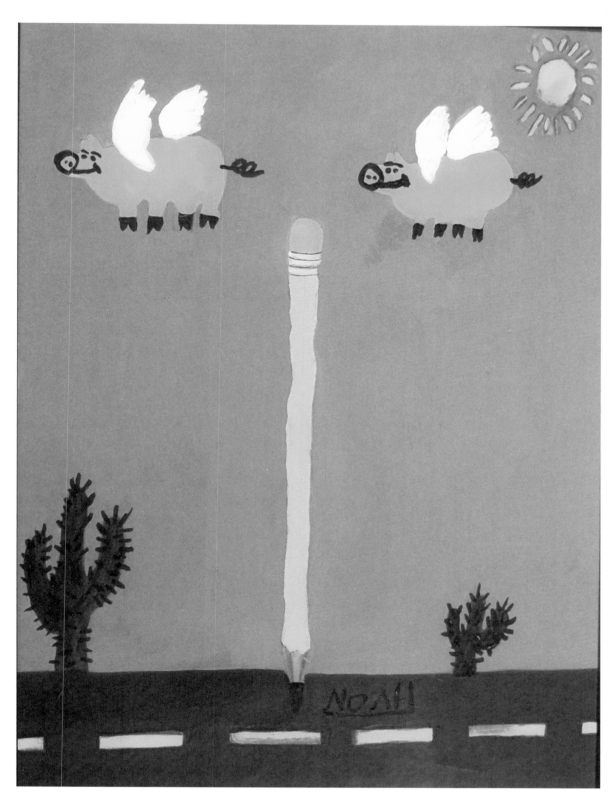

NOAH SCHNEIDER: WHEN PIGS FLY; ACRYLICS; 14 X 20 INCHES; 2007 (AT AGE 13).

**What was the inspiration for this piece?**
I heard the expression ("When pigs fly") and this is what I saw.

# IT'S ALL HISTORY

CHAPTER SIX

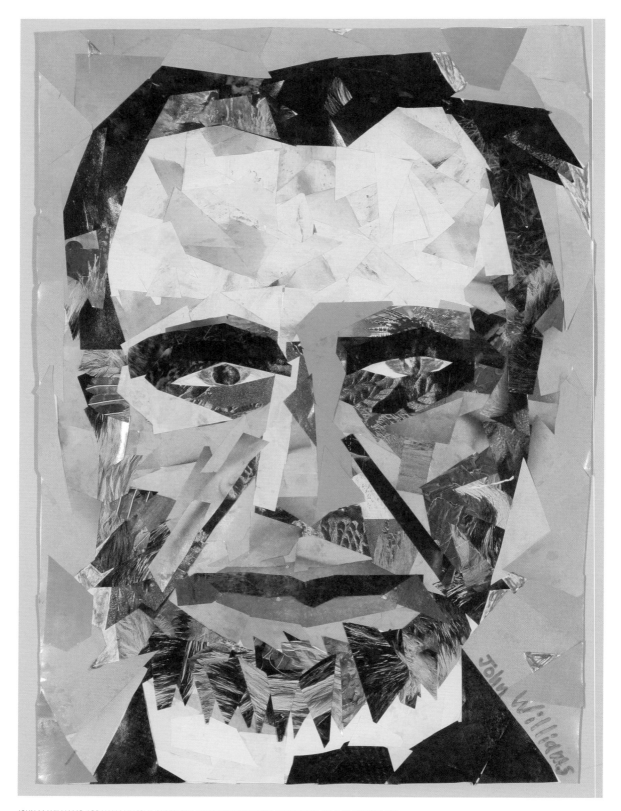

JOHN M. WILLIAMS: ABRAHAM LINCOLN; PAPER COLLAGE (PAPER CUT FROM MAGAZINES); 8½ X 12 INCHES; 2008.

**What inspires/excites you about creating art?**

When I see something inspirational like a beautiful Western scene or learn about an inspirational character from history, like Lincoln, I impulsively want to create a collage to capture the essence of the person or the place. I enjoy creating a coherent image from many tiny pieces of paper—order out of chaos.

**What was the inspiration for this piece?**

Lincoln is my favorite president. His words speak to me. He served at such a critical time in history. I tried to show in his face his wisdom and his humanity—the strain of dealing with so many serious issues, both personal and public.

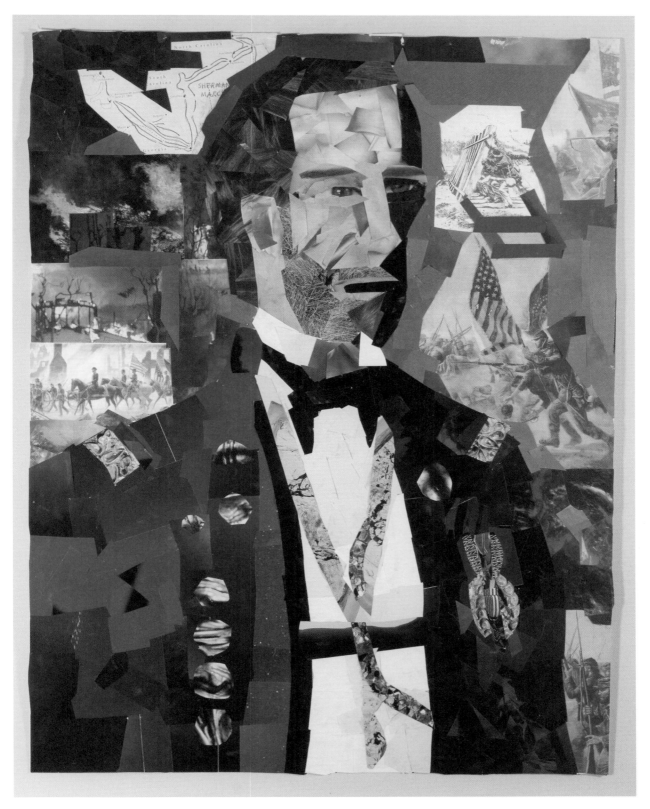

JOHN M. WILLIAMS: GENERAL WILLIAM TECUMSEH SHERMAN, THE FACE OF AMBIGUITY; PAPER COLLAGE (PAPER CUT FROM MAGAZINES); 18 X 24 INCHES; 2008.

### What was the inspiration for this piece?

General Sherman was an iconic figure of the nineteenth century. He was a towering figure in both the North and the South. I studied his life and learned that he had many sides. He had worked in the South and had many friends there, but his job as a general was to break the South's spirit to end the war. I call my piece *General* *William Tecumseh Sherman, the Face of Ambiguity* because of the many sides of his personality. I tried to show that in his face with shading from light to dark, and with the contextual images representing burning of the South on one side and the triumph of his soldiers on the other.

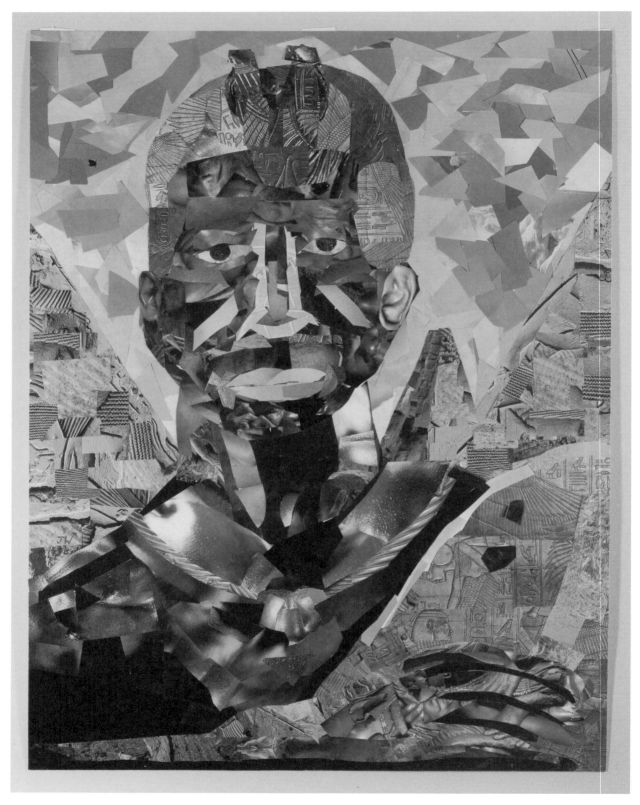

JOHN M. WILLIAMS: PHARAOH, THE FACE OF ETERNITY; PAPER COLLAGE (PAPER CUT FROM MAGAZINES); 23 X 17½ INCHES; 2008.

**Do you think your art helps others understand how you view the world?**
Yes. I think my work is an analogy for Asperger's syndrome, which is characterized by an overload of sensory input. Through my collages I try to make sense out of chaos while also providing a new perspective on my subject.

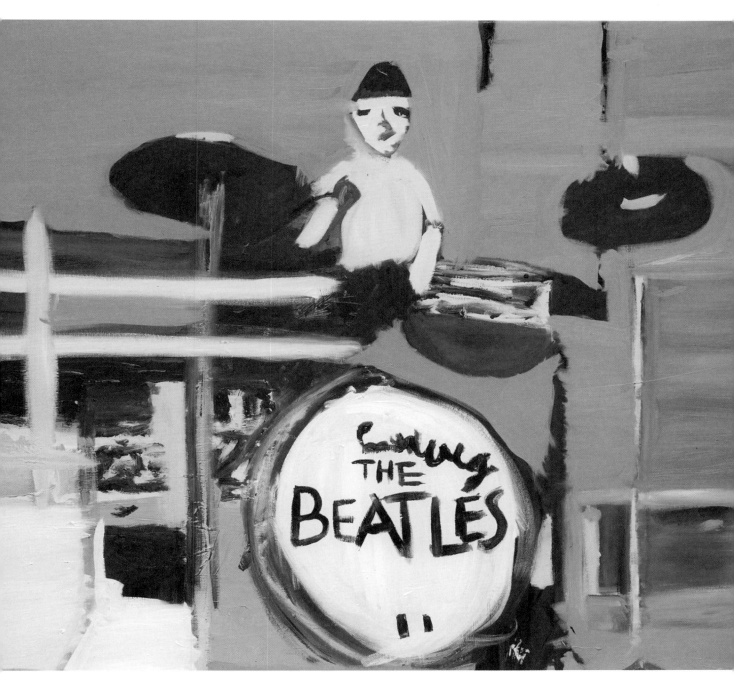

KEVIN HOSSEINI: BEATLES; BLACK & WHITE OIL; 50 X 48 INCHES; 2006 (AT AGE 12).
COURTESY OF THE RHYTHMIC ARTS PROJECT.

**What was the inspiration for this piece?**
I like drumming and I play the drums.

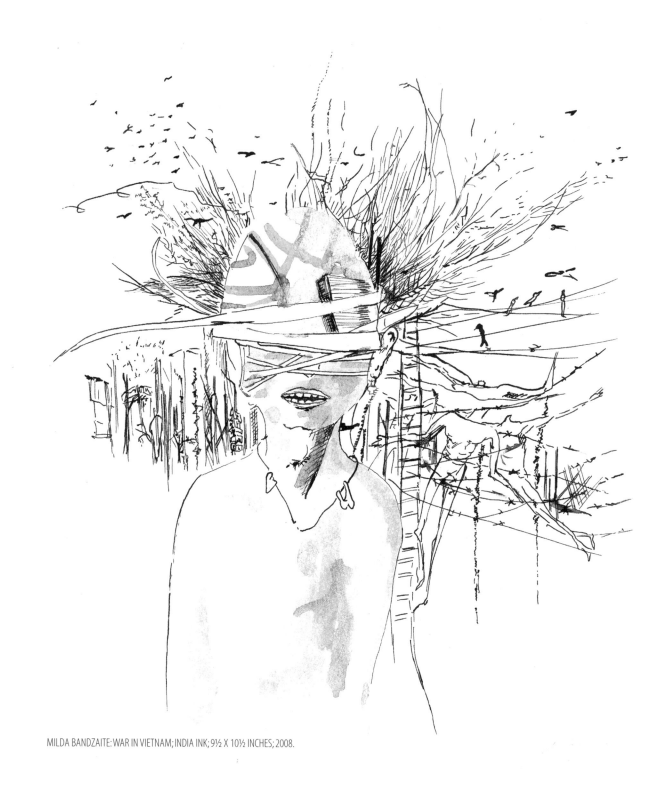

MILDA BANDZAITE: WAR IN VIETNAM; INDIA INK; 9½ X 10½ INCHES; 2008.

**What was the inspiration for this piece?**

This was inspired by all wars in the world and people's indifference for all bad things. And also it was inspired by the lyrics of the Project Pitchfork song "Vietnam": "Now those people who sent me to their war forbid me to speak about the things I saw . . . about the love, about the pleasure, about the youth I lost in a war."

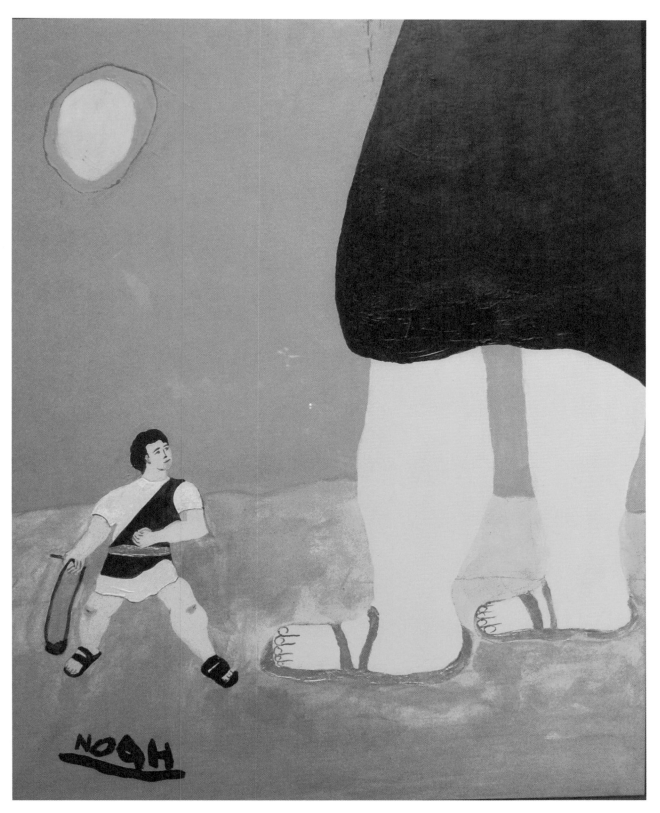

NOAH SCHNEIDER: DAVID VS. GOLIATH; ACRYLICS; 16 X 20 INCHES; 2008 (AT AGE 14).

**What was the inspiration for this piece?**
I learned about this story from the Bible.

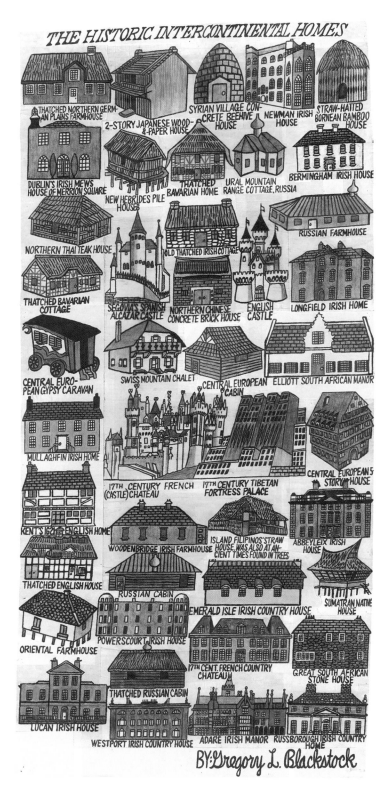

GREGORY L. BLACKSTOCK: THE HISTORIC INTERCONTINENTAL HOMES; MARKER AND GRAPHITE;
50 X 23 INCHES; 2001. COURTESY OF GARDE RAIL GALLERY.

**What inspires/excites you about creating art?**
I don't know how to answer that.

**How do you choose your subjects? Why do you paint/draw what you do?**
That's a hard question for me.

**Do you think your art helps others understand how you view the world?**
(No answer)

**Who are some artists that you like?**
I don't know any other artists.

**What was the inspiration for this piece?**
I don't know how to answer.

**Anything else that you'd like to say about your artwork?**
No.

JESSICA PARK: THE MARK TWAIN HOUSE WITH THE DIAMOND ECLIPSE AND VENUS; 13 X 19 INCHES; 1999.
COURTESY OF PURE VISION ARTS.

**[From Jessica Park's website]**
Jessica works from sketches and then refers to photographs. She uses acrylics, mixing colors to a particular shade, and there will often be seven or eight shades of the same color which will be applied one by one according to a diagram that she holds in her mind from the beginning.

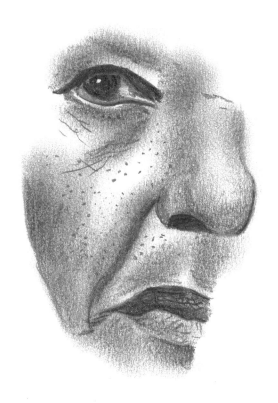

David Barth
2011

DAVID BARTH: MANDELA; PENCIL ON PAPER; 8 X 6 INCHES; 2011.

**What inspired this piece?**
I heard about Mandela's life and found it interesting to make a
half portrait of his face. Old faces are more interesting to draw
than young ones. You can often see wisdom on old faces. I al-
ways try to draw as little as possible. As soon as one can see
who it is, I've done enough.

# ART FOR ART'S SAKE

CHAPTER SEVEN

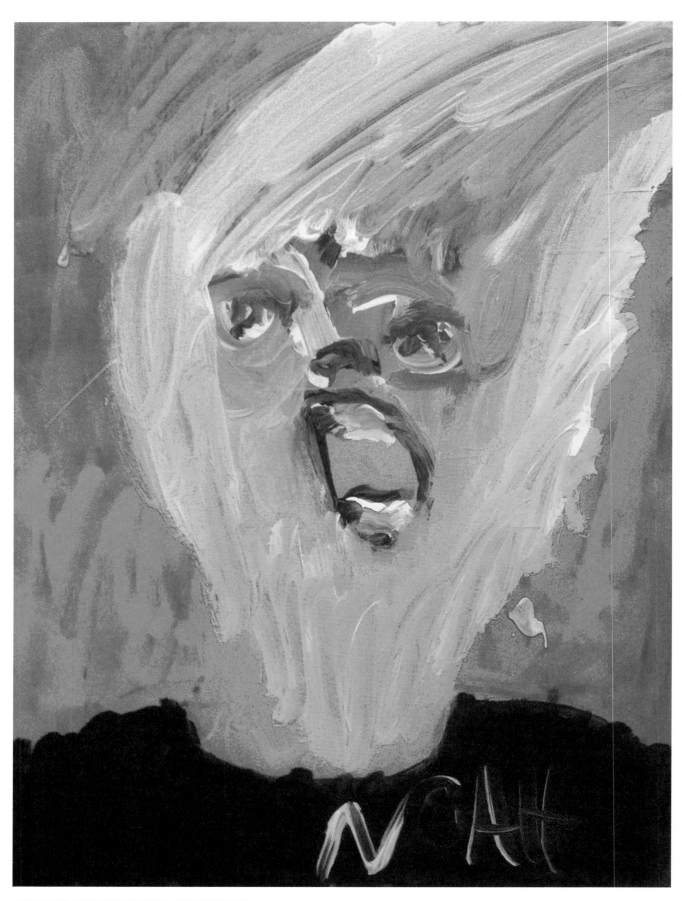

NOAH ERENBERG: HEAD 7; ACRYLIC ON CANVAS; 18 X 14 INCHES; 2013.

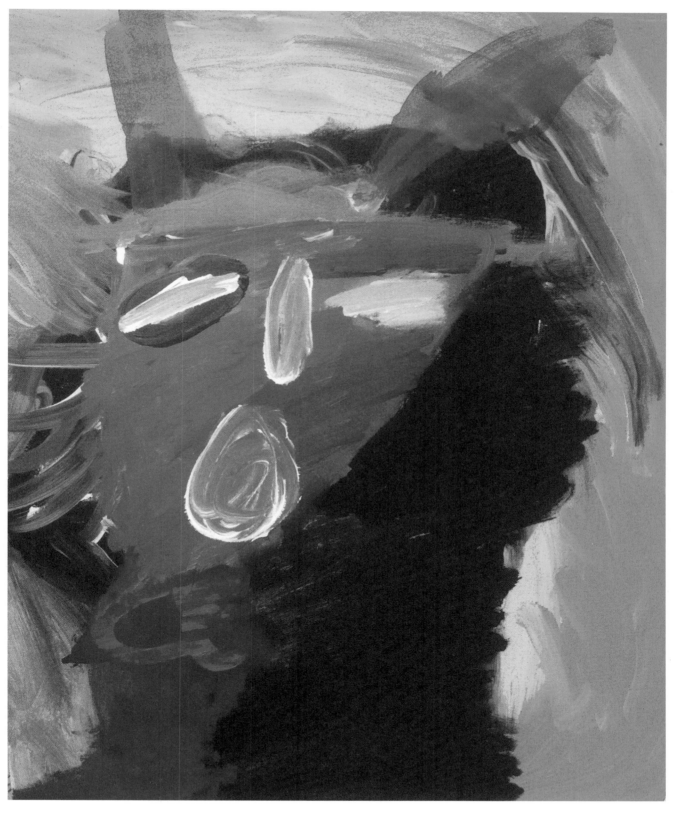

NOAH ERENBERG: HEAD 4; ACRYLIC ON CANVAS; 20 X 24 INCHES; 2013.

DANIEL G. MULLER: LIGHT AT THE END OF A TUNNEL; PAINT AND MARKER; 8 X 12 INCHES; 2002.

**What was the inspiration for this piece? [answered by mother]**

Danny painted this in a psychiatrist's office. I can only assume that he reacted to what the psychiatrist and staff of the group home were talking about in his presence. Whatever staff was saying, it was usually dark and negative. I guess the negative was represented by the blue walls in the painting and the red in the center . . . Well, I am guessing that he felt that every reason for optimism was being squished . . . or, perhaps, he thought there was light at the end of the tunnel . . . We will never know and he is not telling.

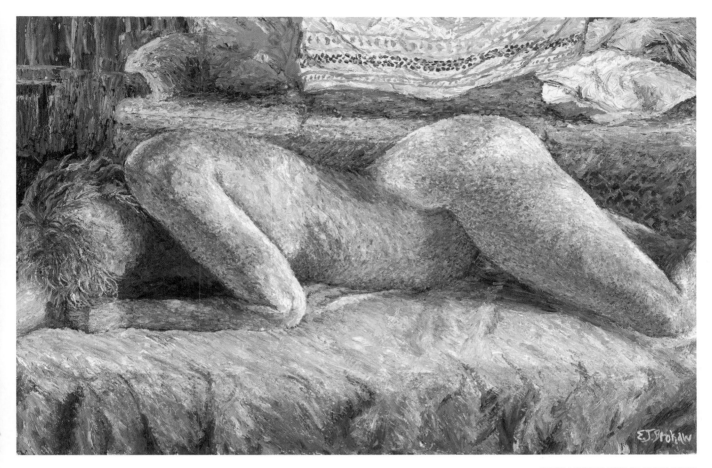

ESTHER J. BROKAW: NUDE; OIL; 20 X 30 INCHES.

**What was the inspiration for this piece?**
I was inspired by this body position; I liked the lines. I wanted to play with colors in the shadows of the body in an impressionistic, even pointillism style. Not having a model, I used myself and a camera with a timer. This was my third oil painting.

KEVIN HOSSEINI: GAUGUIN AND ME; OIL; 24 X 24 INCHES; 2004 (AT AGE 10).

**What was the inspiration for this piece?**
I painted this after looking through an art book.

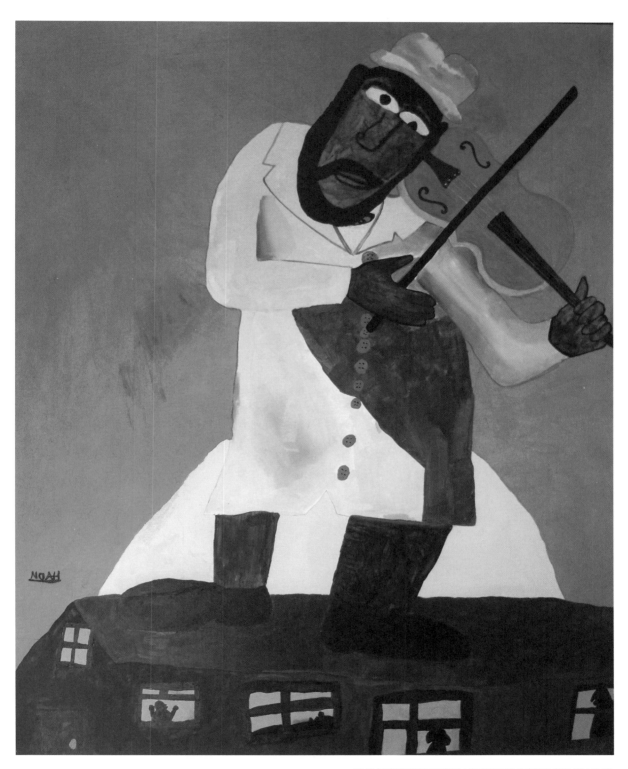

NOAH SCHNEIDER: THE FIDDLER; ACRYLICS; 32 X 40 INCHES; 2007 (AT AGE 13).

**What was the inspiration for this piece?**
I combined images I had seen and I liked the play called *Fiddler on the Roof*.

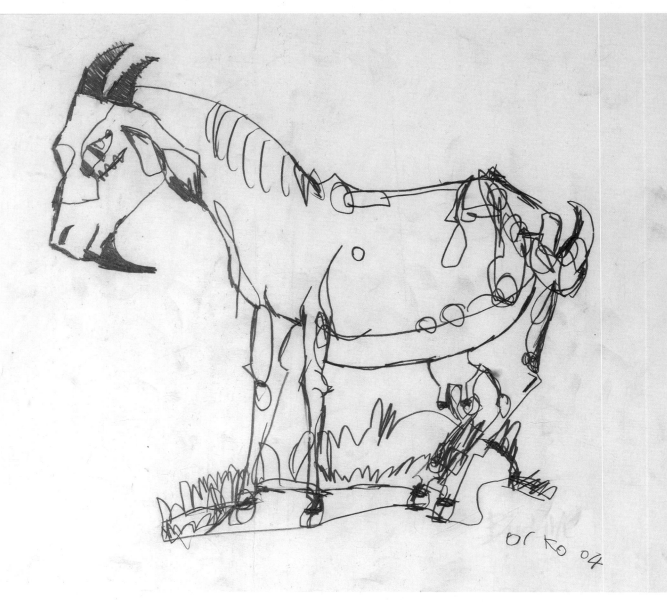

ORKO ROY: THE ANGRY GOAT; PENCIL; 15 X 20 INCHES; 2004 (AT AGE 14).

**Why did you start creating art? [answered by father]**

When he saw me paint, he was very fascinated. Then we gave him a paint brush and some paint to play with. Seeing the effect of changing shades with various combinations of colors seemed to amuse him.

Orko is autistic and is epileptic. As a result he has not been able to attend normal school and until the age of eleven has had serious motor control problems—he wouldn't be able to hold a pencil properly to write a sentence. He surprised all when he took to art by converting his motor control weakness into his strength by drawing bold uninterrupted lines.

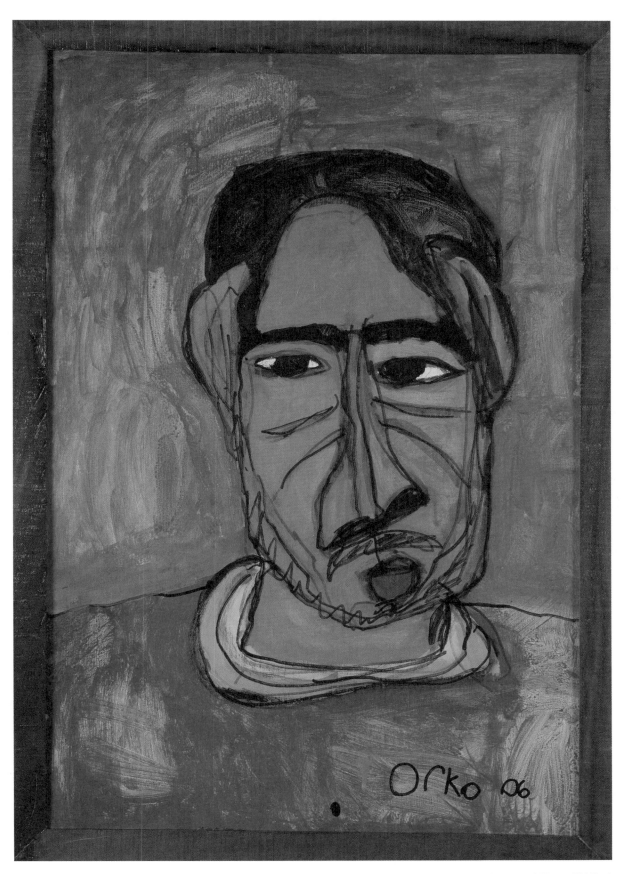

ORKO ROY: SELF PORTRAIT; ACRYLIC; 36 X 24 INCHES; 2006 (AT AGE 16).

SHELBY RAE McSWEENEY : FARM KITTIES; 11½ X 14 INCHES; ACRYLIC PAINT ON CANVAS PAPER; 2012.

**What inspired this piece?**
I painted *Farm Kitties* for my Mom-Mom because she misses her husband, my Pop-Pop. He was from West Virginia and they would take trips there. I love painting and drawing all kinds of cats and kittens and I want my art to make people happy.

WESTLEY CEDENO: "UNTITLED"; 5 X 5 INCHES, CHARCOAL ON BRISTOL PAPER; 2009.

**What inspired this piece?**

This charcoal art piece was done through experimenting with different texture shadings from different objects around my house and cut-and-pasting them onto my Bristol paper. The image is from my childhood memory of looking at the wooden swing set by the ocean. I loved going on the swing every single time I was at the beach or at the park.

What inspires me to create art is the vibrancy of colors, hues, and the representation of different textures. In addition, I love to create, experiment, and be open with the arts. I also admire reading positive quotes from people. Anything in art is valid.

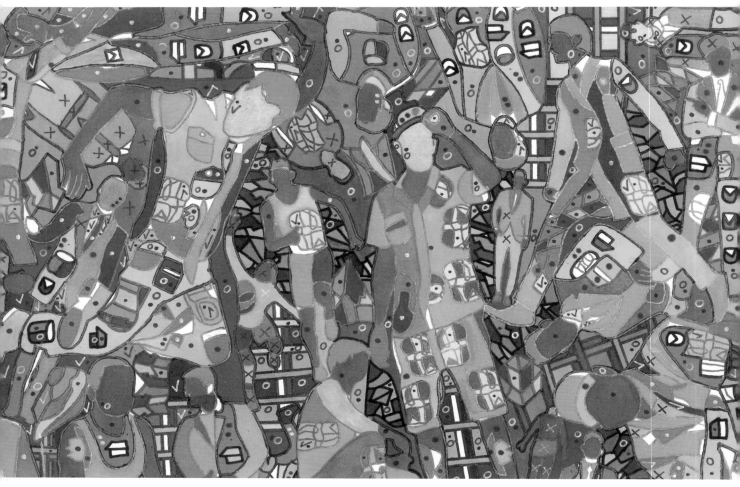

BARRY KAHN; UNTITLED; INK ON PAPER; 12 X 18 INCHES; 2012. COURTESY OF PURE VISION ARTS.

**[from Pure Vision Arts]**
Passionate about drawing since the age of three, Barry began attending the Pure Vision Art studio in 2005.

Working with ink on paper, Barry creates unique drawings that juxtapose intricate geometric patterns with human figures. Many of these surrealistic drawings are unsettling and many are inspired by actual dreams and nightmares. To quote Barry, "My drawings are like dreams in that sometimes they don't make sense."

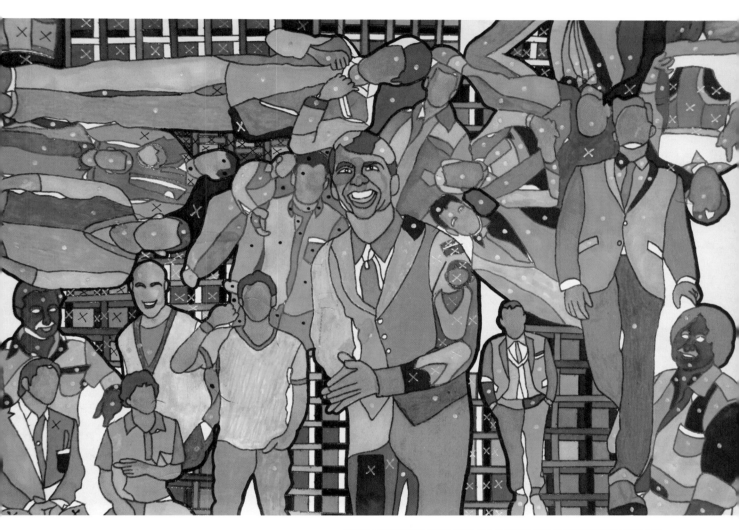

BARRY KAHN: UNTITLED; INK ON PAPER; 12 X 18 INCHES; 2012. COURTESY OF PURE VISION ARTS.

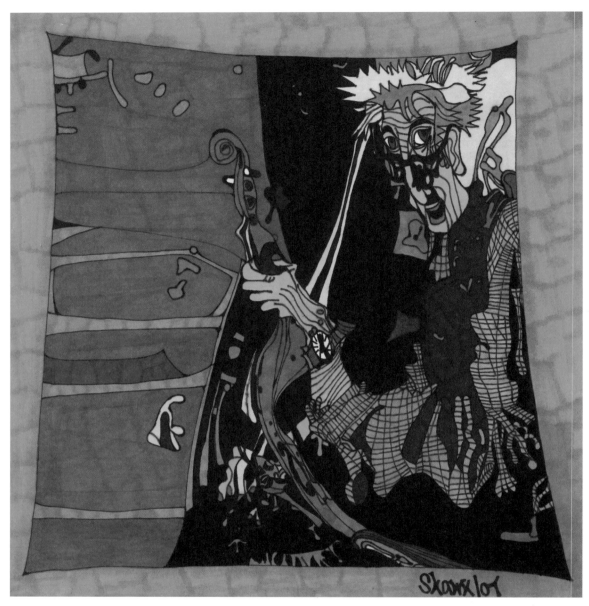

SHAWN BELANGER: MUSIC MAN; MARKERS AND INK; 14 X 14 INCHES; 2007.

**Anything else that you'd like to say about your artwork?**
**[answered by mother]**

Shawn has very little conversational speech and usually does not like to draw attention to himself. Shawn has become very adept at handling compliments about his work. He has a look of pride on his face that we never thought we would see when he first began to draw seriously in high school. He comes down and reads each e-mail that he receives on his website, never comments on it but again has a look of pride on his face. The intensity that Shawn draws with is amazing. There is a look of concentration that is intense, one gets the feeling that for that period of time the world ceases to exist.

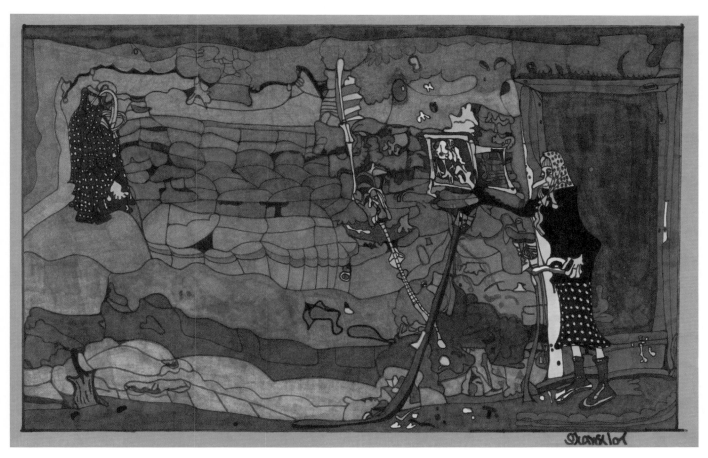

SHAWN BELANGER: STONE HOUSE; MARKER AND INK; 12 X 14 INCHES; 2007.

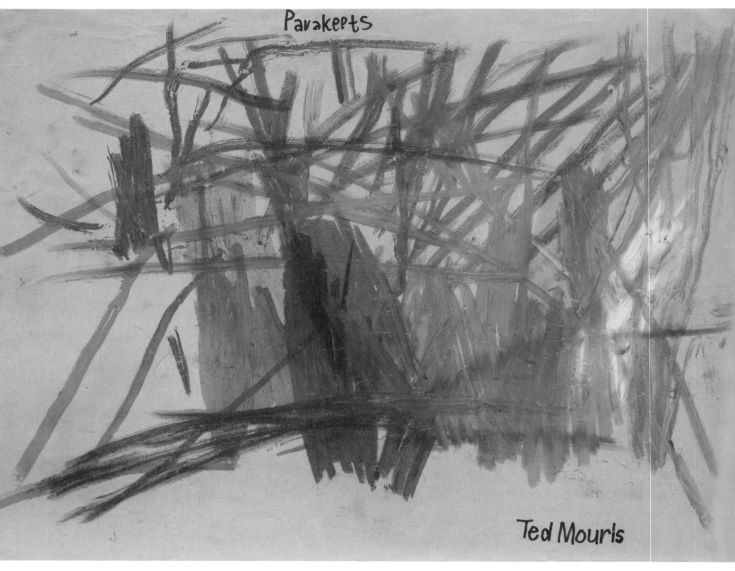

Parakeets

Ted Mouris

TED MOURIS: PARAKEETS; OIL PASTELS; 24 X 17½ INCHES; 1998.

**What was the inspiration for this piece? [answered by mother]**
In *Parakeets*, Ted's orange cat knocked the birdcage down very fast, spilling the blue water everywhere.

**At what age did the act of creating art enter into your life?**
As soon as Ted could hold a crayon in his fist he started drawing. At age three, he found a pencil and printed the entire alphabet on the garage floor. No one taught him this; he just saw it on *Sesame Street*.

**Do you think your art helps others understand how you view the world?**
Ted lives day to day very quiet, but still waters run deep. His joy of life comes out in his artwork.

**What inspires/excites you about creating art?**
Ted becomes very calm when he creates art. He sees something that gets his attention and he is very happy when he can recreate it.

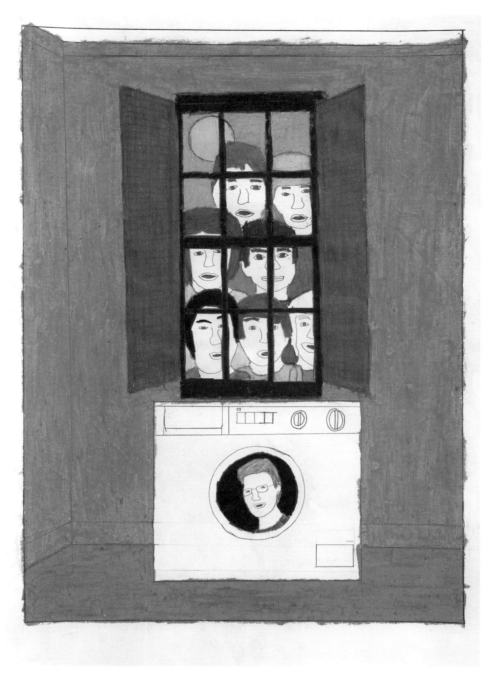

TRISHA FERGUSON: WASHING MACHINE AND CHOIR; COLORED PENCILS; 11½ X 8¼ INCHES; 2008.
COURTESY OF TUTTI VISUAL ARTS AND DESIGN PROGRAM IN AUSTRALIA.

**What was the inspiration for this piece?**
I love [my friends from the art center and choir] and thought it would be fun to put them in a washing machine.

**Why did you start creating art?**
Because I love colors.

**What inspires/excites you about creating art?**
To feel like I have achieved something that people like.

**How do you choose your subjects? Why do you paint/draw what you do?**
I just get ideas.

**Do you think your art helps others understand how you view the world?**
Yes, especially my sense of humor.

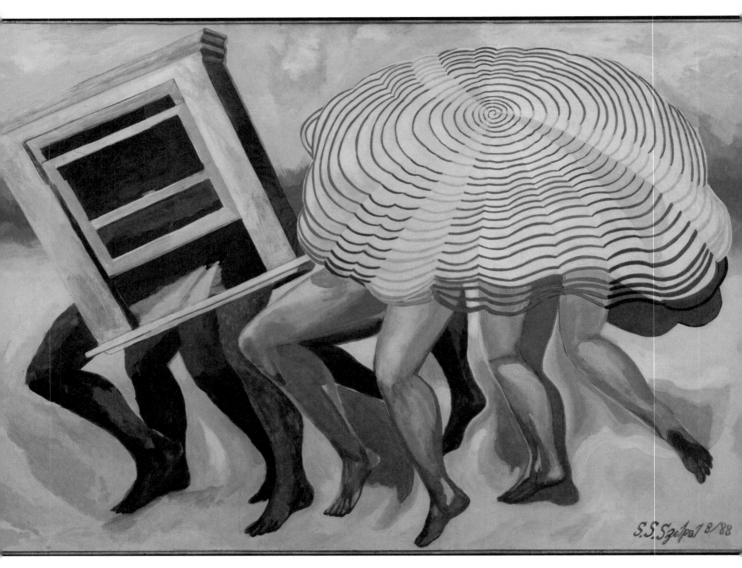

STEVEN SANDOR SELPAL: INSIDE-OUTSIDE VORTEX FROM "DREAM SERIES" (DREAM DATE DECEMBER 23, 1987);
ACRYLIC ON CANVAS, 61 X 48 ½ INCHES, 1988.

### What inspired these pieces?

These two dream paintings were done during the decade when I was avidly journalizing my dreams, writing scrawl and quick sketching upon awakening. From autumn 1987 until 1997 I painted as many dreams as I could. In these two dreams I was a passive observer, not a protagonist, passing through, and I remembered what I saw.

In *Inside-Outside Vortex*, there was a *homo robustus* man's legs carrying a standard mid-twentieth-century wooden window. In the window there was street activity and cars driving by at night. The swirls erupted from the car's bright headlights as a retinal fatigue effect on the eyes. The swirls of colors had an up-and-down movement like dancing, then clearly the reason why was shown when it was apparent that a modern woman's legs were in fact dancing, carrying along the colorful swirl.

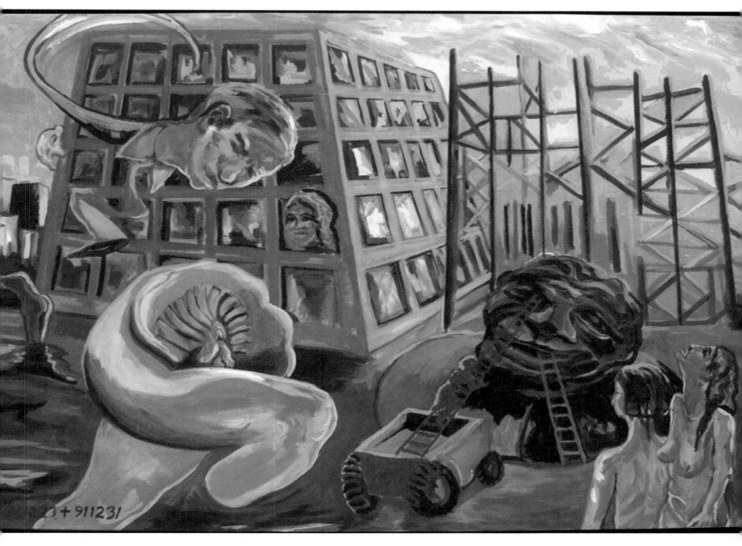

STEVEN SANDOR SELPAL: THE GREAT LIVING HEAD SCULPTURE FROM "DREAM SERIES" (DREAM DATES DECEMBER 23, 1991 AND DECEMBER 31, 1991);
ACRYLIC ON CANVAS, 47½ X 36 INCHES; 1995.

In *The Great Living Head Sculpture,* there were two dreams that were related. In both dreams I was walking along the same downtown street in the morning, close to a public square, vaguely similar to Public Square in Cleveland. In the first dream I could hear an argument between a young office worker man with a necktie and white collar and a woman office worker. They were both on the phone, but on different floors. There was an old janitor listening at the same time. Because I was listening too, the young man lunged toward me, angrily. In the public square were large bronze sculptures in the style of Henry Moore and a large head that was like an Auguste Rodin sculpture. There were workers around the great head and I was startled to see the eyes rolling and the lips moving, as if it were alive. I was gazing at this with two women who were waiting at a bus stop on their way to work. Although the women were naked, it seemed unremarkable at the time, because as I was observing all this, I was naked too.

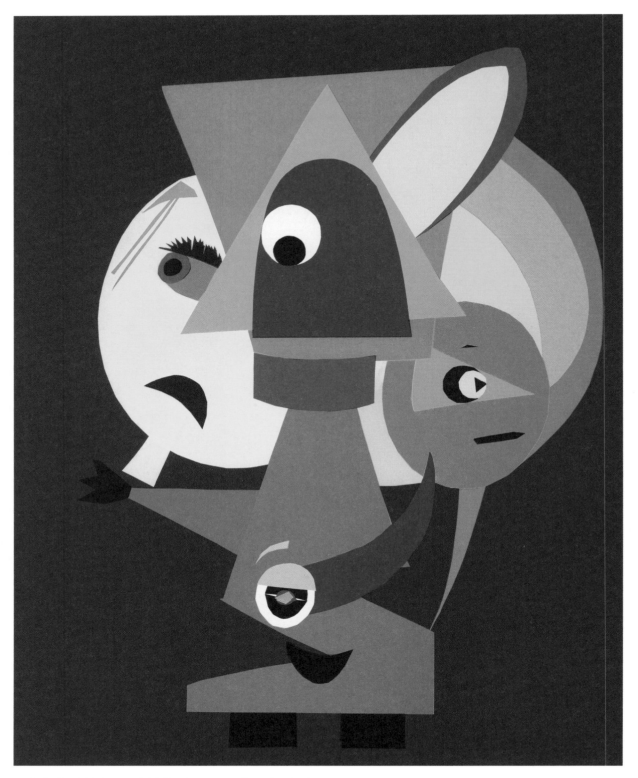

WIL C. KERNER: PALS; CONSTRUCTION PAPER COLLAGE; 20 X 25 INCHES; 2007 (AT AGE 12).

**What was the inspiration for this piece? [answered by grandmother]**
The key in understanding *Pals* is the brown-rimmed, off-white donkey ear. Four facial expressions depict the bad boys turning into donkeys in the movie *Pinocchio*: purple-faced Pinocchio is stunned by his new ear and considering what to do; it's too late for the horrified yellow face; the green trapezoid is oblivious to his pending fate; the blue head is looking away, hoping he's not included.

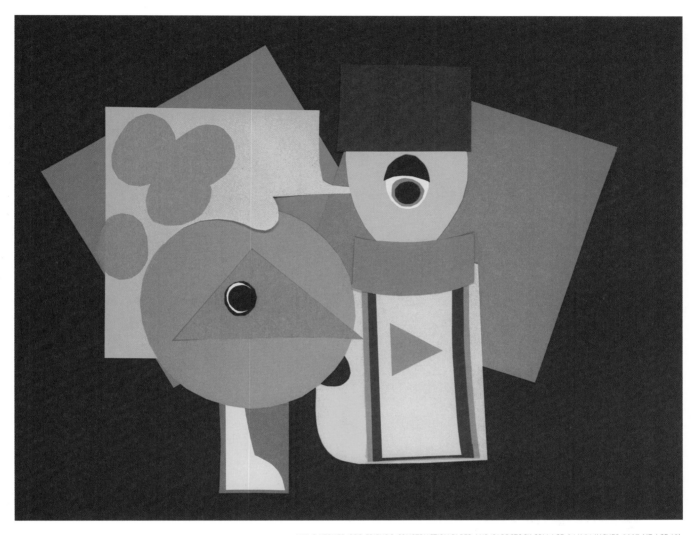

WIL C. KERNER: ODD FRIENDS; CONSTRUCTION PAPER AND CARDSTOCK COLLAGE; 26 X 21 INCHES; 2007 (AT AGE 12).

**What was the inspiration for this piece? [answered by grandmother]**

This piece wonderfully represents Wil's extraordinary love of shapes and colors, as well as his deep emotional desire for friends. He was not viewing anything when he created this, and it took him quite awhile before he pointed to the fact that neither character has ears or a mouth. The yellow cutout topped with red egg-like cutouts that is attached to the smaller character touches the larger character where an ear would otherwise be, which implies that they exchange their thoughts and feelings through this funnel. Having no mouths implies they live very differently than humans and other living animals. Apparently they thrive but do not eat. Wil did his best to convey all this with a few short words: "No ear, no mouth, no eat . . . friends!"

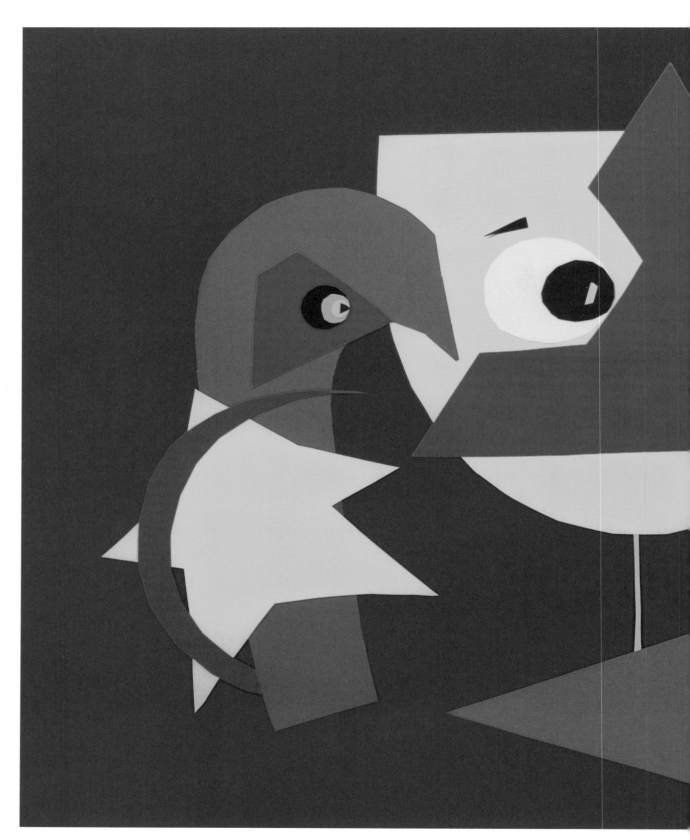

WIL C. KERNER: BIRD AND BOY; CONSTRUCTION PAPER COLLAGE; 20 X 17 INCHES; 2007 (AT AGE 12).

**What was the inspiration for this piece? [all below answered by grandmother]**
This piece suggests that looking different does not mean you are. It also suggests that being different can assist friendly bonds even between two different species, and that hiding behind a mask can be a colorful way to view the world. Wil created this piece while watching the *Hey Arnold!* episode "Pigeon Man," wherein Arnold takes his sick bird to the Pigeon Man who is thought to be crazy by many because he lives on a rooftop with only pigeons. Of course the Bird Man is kind and intelligent and simply appears different and he and Arnold become instant friends.

**Why did you start creating art?**
Wil clearly has an inherent need and passionate drive to create an emotional connection to his creations. While his iPad lets him travel through YouTube, his present source of ideas for his creations, his developed obsession for stacks of colored papers, continues to grow and cover practically every surface at home.

**What inspires/excites you about creating art?**
No doubt, Wil is on a personal quest to develop his style and technique, as any artist does. He's also inspired to create video/DVD characters in order to make them somewhat real in his personal space. He truly enjoys cutting into color, and always enjoys verbally identifying his character-creations by their colors.

**How do you choose your subjects?**
Wil chooses his subjects from videos and DVDs that he obsessively replays. Once determined, typically by some fondness he has developed for the character, he begins cutting it in identical colors but never identical appearance. Wil thrives on creating his own abstract renditions.

**Anything else that you'd like to say about your artwork?**
People generally are fascinated with the graphic design look Wil produces with his scissors and paper. They become even more fascinated with Wil and his art when they realize he has classic autism. While Wil's speech is quite limited, his art seems unlimited and is a great topic of conversation between Wil and onlookers; Wil being the obedient listener!

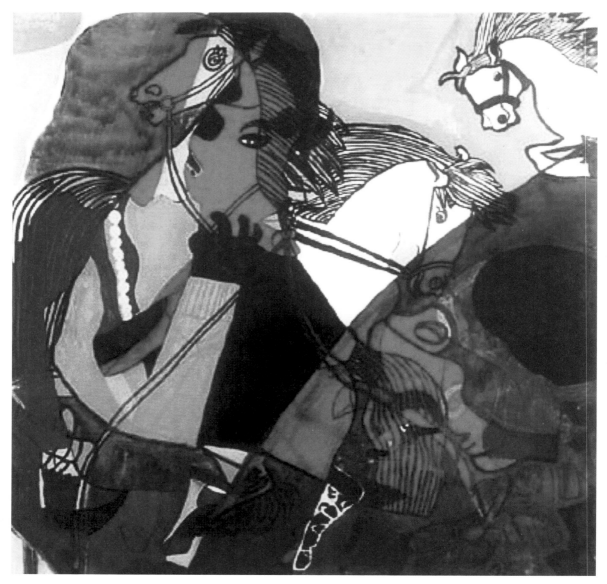

ROHAN SONALKAR: HORSES AND HUMANS: A MELANGE; ACRYLIC; 3 X 3 FEET; 1995.

**[From "Goodbye, Rohan" by Leena Saldhana]**
His work was an inferno of color. And sometimes, quite
unexpectedly one could catch a glimpse of a tortured mind
struggling to express itself. In the angry splash of red, in the
surprising distortion of an image. But on the whole Rohan painted
blissfully, even cheerily. He painted his universe.

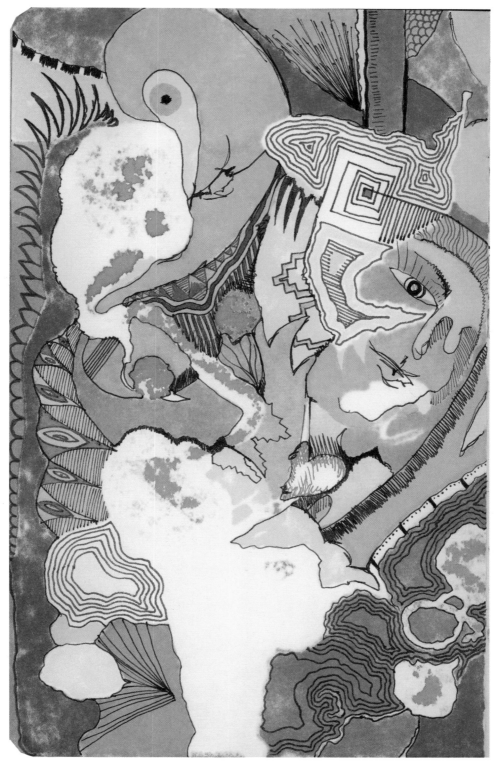

EMILY L. WILLIAMS: FRIDA; INK AND SHARPIES; 5 X 8 INCHES.

**Who are some artists that you like?**
I love Frida Kahlo, not just because of her work (there's actually some of it I don't especially like) but because of her as a person. She and her husband, Diego Rivera, were larger than life—their entire lives were works of art. Everything they did seemed large: incredible joys, absolute pain, excruciating sorrows.

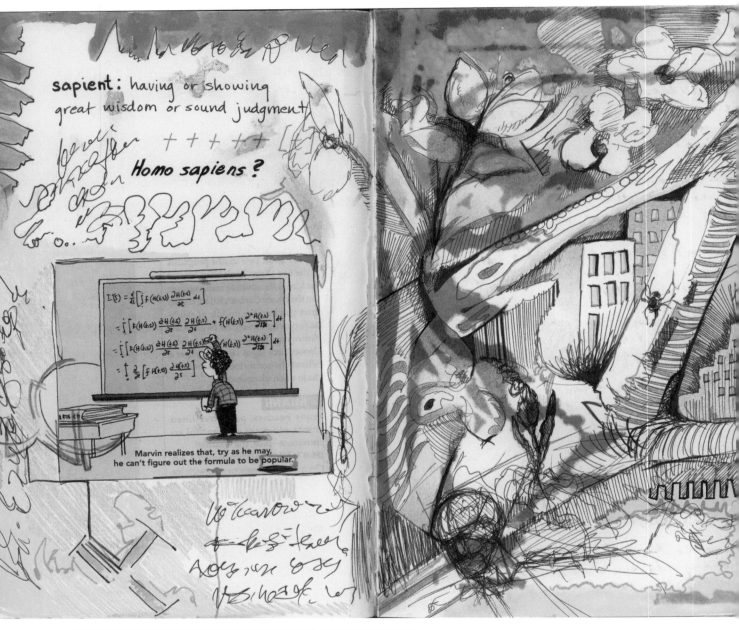

EMILY L. WILLIAMS: POPULARITY; INK, PRISMACOLOR PENCILS, SHARPIES, AND COLLAGE; 10 X 8 INCHES.

**Do you think your art helps others understand how you view the world?**
Not especially. At least not to any considerable extent. Of course, any person can tell I'm obsessive-compulsive by the style of much of my work. But the subjects of my work don't usually lend a considerable amount of insight into who I am as a person. Art for me is about creating something visually pleasurable.

Attempting to express emotion via my work is not something I'm comfortable with and most times don't feel capable of. Emotion is too powerful and I rarely seem to be capable of capturing much of it on the canvas.

EMILY L. WILLIAMS: LEAP YEARS; INK, PRISMACOLOR PENCILS, INDIA INK, WATERCOLOR, AND COLLAGE; 10 X 8 INCHES.

EMILY L. WILLIAMS: SWEET AND SWEET; INK, PRISMACOLOR PENCILS, SHARPIES, AND COLLAGE; 5 X 8 INCHES.

**Why did you start creating art?**

I'm not certain. I can't remember why I began drawing. I suppose simply because I could. In school, one is inevitably asked to do small projects that involve some drawing. And it didn't take long to discover that I had a particular talent above and beyond many of the other students. And it didn't take the other students long to discover that as well. So I drew because I was good at it, because it was asked of me in a school setting, and because it gained me admiration from teachers and other students. For a child not blessed with the greatest social skills, being known as "the artist" isn't a bad thing.

**How do you choose your subjects? Why do you paint/draw what you do?**

I never know why I create art except that at the time, I want to do it. The subjects of my drawings and paintings are rarely planned, and if there ever is planning it's usually minimal because 99% of the time, partway through the drawing, it turns into something I hadn't intended. So I try not to intend much.

The concepts I integrate into my work are rarely complex or abstract, and if they are it's usually an after-the-fact coincidence. My purest goal is to create what visually pleases me: the form, the contrast, the motion. Nothing more than that.

Having taken a fair number of art courses in high school and college, people have inevitably asked me this very question, "Why did you draw it that way?" And if I were writing a thesis on the subject I might make a greater effort to dissect, formalize, and communicate my reasoning to them. However, that aside, the only reason I seem to be able to come up with time and again is, "I liked it, that's why." Language is a fantastic medium, and I feel like I have some talent in that as well. But when it comes to using language to explain my art, I find it daunting. Art is so visual for me; I know precisely why I do things the way I do them in my artwork. It's not as though I have no idea what I'm doing. But it's not a language-based knowledge. So to be asked "Why?" and to have to try to translate my visual reasoning into words feels almost impossible and I'm usually left dumbfounded by the task.

# ARTISTS' BIOS
## & ART INDEX*

*Page numbers in **BLUE.**

**Kay Aitch** was diagnosed with Asperger's syndrome when she was fifty-one years old, so she is very young in this new-found existence. www.facebook.com/artistkayaitch **17, 33, 92**

Born in 1990, **Milda Bandzaité** is a Lithuanian art student based in Germany. www.aiws.lt **38, 39,120**

Born in 1998, **David Barth** started creating at a very young age. His obsessions inspire him to draw with great attention to detail. He has won several prizes for his work and has illustrated two books. His first solo exhibition was on view from December 2011 until January 2012 at OPPERCLAES., a gallery in Rotterdam. His work has also been shown in China, at the C-NA Gallery and the Inside-Out Art Museum. www.davidbarth.nl **56-57, 64-65, 102-103, 125**

**Shawn Belanger** showed an intense interest in art from an early age, developing a singular visual style. Belanger's attention to detail and his vibrant use of color allow him to turn the simplest of photographs into amazing pieces of art. www.shawnbelanger.com **42, 43, 58, 59, 78-79, 140, 141**

**Gregory L. Blackstock's** drawings have been featured at the John Michael Kohler Arts Center in Sheboygan, WI, at the Outsider Art Fair in New York City, and at the World Autism Awareness Day at the United Nations, as well as in numerous solo shows at Garde Rail Gallery and Greg Kucera Gallery. In Europe, Blackstock's work has been part of exhibitions in both Vienna and Zurich. In 2011, the prestigious museum, Collection de l'Art Brut in Lausanne, Switzerland presented a solo exhibition for Blackstock, and thirteen of his works now reside in their permanent collection. He is represented by Greg Kucera Gallery, Seattle, WA, (www.gregkucera.com) and by Garde Rail Gallery, Austin, TX. (www.garde-rail.com). **62, 63, 122-123**

Born in 1984, **J.W. Bridges** is from Mattoon, IL. Although officially diagnosed with Asperger's syndrome at twenty-two, art has always been a part of his life. He works at the Mattoon Public Library. For more art and information, visit his Facebook page: J.W. Bridges Art. **32**

As a child, **Esther J. Brokaw** showed extraordinary art ability, though she was not encouraged to pursue her talent until she was thirty years old. She was diagnosed with Asperger's syndrome in 2004. She is married, has two daughters, and creates impressionist oil paintings of scenes that she finds beautiful. www.savantgallery.com **83, 86-87, 131**

Born in 1957 on Long Island, New York, **Susan Brown** currently lives in Sayville, New York, with her mother. She was diagnosed with autism when she was a young child. Her art reflects an eclectic interest in portraiture, transportation, and landscapes. Her imagery is based on actual prodigious memories and life experiences. Since 2002, Brown has attended New York City's Pure Vision Arts, The Shield Institute's studio for artists who have developmental disabilities. **45, 50, 76, 77**

**Justin Canha** began his artistic career at the age of thirteen with the support of Arts Unbound, a New Jersey–based nonprofit organization dedicated to the artistic achievement of people with disabilities. The Ricco/Maresca Gallery in New York City has represented Canha since he was fifteen years old. www.justincanhaart.com **28, 29, 30-31**

**Westley Cedeno** is a student at Florida Atlantic University studying for a Bachelor of Fine Arts in Studio Art. After he graduates he plans on going for a second bachelor's degree in the medical field. He loves to read books, work out at the gym, collect coins, make ceramic jewelry and crafts, cook, hang out with friends, laugh, and live life to its fullest. etsy.com/shop/TheElfMonkey **137**

Born in 1991, **Vrinda Chaswal** lives in New Delhi, India, with her parents. She has been painting for the past ten years and her other interests include collecting baskets and pencil boxes. Chaswal is also a very skilled weaver on manually-operated looms. **85**

Born in Singapore, **Eric Chen** was diagnosed with autism in 2001. He has a degree in logistics and is the author of two books, *Mirror Mind: Penetrating Autism's Enigma* and *Autism & Self Improvement*. www.iautistic.com **24-25**

Born in 1999, **Bailey Clark** lives in North Carolina. He enjoys drawing pictures, cars, swimming, movies, and video games. He is a perfectionist with his artwork, drawing more than thirty pictures per day but keeping only four or five. **70, 71**

Along with her collages, **Marilyn Cosho** makes miniature fairy chairs out of twigs. She has also created a seven-minute DVD titled *Welcome to the Asperger Syndrome Mind*. **12, 36-37, 51**

Born in 1983, **Marcy Deutsch** was diagnosed with moderate to high-functioning autism at age five. Deutsch began to create art as a result of a school assignment, which unlocked her talents. She lives in Yelm, Washington, and won the 2008 Yelm Arts Walk poster contest. www.crittersonthings.com **95**

Born in 1994, **Wout Devolder** lives near Antwerp, Belgium. **44**

**Noah Erenberg** has been an artist since 1990. He paints and draws because it makes him feel wonderful. He is represented by Elizabeth Gordon Gallery in Santa Barbara, CA. www.saatchionline.com/erenberg88 **52, 53, 54, 55, 74, 128, 129**

**Trisha Ferguson** is an artist with the Tutti Visual Arts and Design Program, based in Adelaide, Australia. She produces strong design pieces that reflect her love of bright colors and geometric patterning. She is interested in the complexities of perspective and throws herself into the challenges of rendering buildings, interiors, and window views with determination. **143**

**Temple Grandin**, PhD, a renowned author and speaker on the subjects of autism and cattle handling, is considered the most accomplished adult with autism in the world. She is the author of several books, including the best sellers *The Way I See It* and *Animals in Translation*. **8-9, 10, 11**

**Zach Hamm** was diagnosed with autism at age four. In 1989, autism was a word that was never heard of. His family has never accepted that autism is a limiting disability. He has illustrated several books. www.stratfordoakstales.com **66, 67**

**Alexandra Hill** is an artist with the Tutti Visual Arts and Design Program, based in Adelaide, Australia. She produces exquisite images of fantastical creatures, including unicorns, fairies, goblins, and magical animals. Alexandra draws and paints in great detail, using pen and watercolor, a technique in which she can achieve fine line combined with flowing washes of color. **104, 105**

Born in 1994, **Kevin Hosseini** resides in California. He started painting at the age of eight. His art has won numerous accolades and awards and has been used on the cover of CDs, books, and the documentary *ARTS: A Film about Possibilities, Disabilities and the Arts*. www.kevingallery.com **72, 73, 84, 93, 119, 132**

Born in 1979, **Barry Kahn** lives in Rockville Center, New York. Since 2007, his work has been exhibited in numerous shows, including the Outsider Art Fairs in New York City, Vienna, Austria, and Leiden, Netherlands. He is represented by Pure Vision Arts. www.purevisionarts.org **138, 139**

After living the first twenty-five years of his life in the Bronx, New York, **James Kenneally**, along with his parents and his brother, moved to Upstate New York. Kenneally loves architecture. His favorite art activity is drawing buildings. **88, 89**

Born in 1995 and diagnosed with autism at age two, **Wil C. Kerner** is an artist savant who loves cutting characters from colored papers. www.wilspapercutouts.com **146, 147, 148-149**

Born in 1995 in Oklahoma, **Amanda Lamunyon** began painting at age seven and was diagnosed with Asperger's syndrome at age eight. Because art helped her express herself, Lamunyon speaks frequently about painting, singing, and living with autism. www.amandalamunyon.com **82**

**Stephen Mallon** is an architect, 3-D illustrator, web developer, and composer of electronic and art noise. He had never heard of the autism spectrum until a diagnosis placed him on it, enabling him to reinterpret his history through an "Aspie" lens. www.archimg.com **60-61**

**Rachel Marks** is a PhD student from London, England. She was diagnosed as an adult with Asperger's syndrome in 2007. **40**

**Robert Maxwell** lives in England and was diagnosed with Asperger's syndrome in his midthirties. He loves painting and technical drawing. **41**

**Michael P. McManmon** first started drawing trees as a small child. For the first thirty years of his life as an artist, McManmon worked strictly in pen and ink. After being diagnosed with Asperger's syndrome at age fifty-one, McManmon began diving into a world of color, first with watercolors and then moving into pastels. Upon his diagnosis, he learned to embrace his differences and accept himself, knowing he was made exactly the way he was supposed to be. He is the father of six children and has twelve grandchildren. He is a licensed psychologist, author, and the founder of the College Internship Program (CIP), a program that assists young adults with learning differences in attending college, developing careers, and learning to live independently. In 2011, McManmon opened the Good Purpose Gallery in Lee, Massachusetts, a dynamic gallery and work space exhibiting the work of artists on the autism spectrum and those with learning differences. goodpurpose.org **90, 91**

In 1994, **Shelby Rae McSweeney** was born in Hollywood, Florida. She was diagnosed with autism spectrum disorder at the age of three, and did not talk until she was five years old. She started drawing pictures at the early age of two; these daily illustrations informed her parents about the kind of day she'd had. She has always expressed herself through art and enjoys painting with acrylics, sketching, and animation, as well as working with clay. She recently fulfilled her dream of being accepted into the Dillard Center for the Arts. **136**

**Eleni Michael** lives in Norfolk, England, and was diagnosed with Asperger's syndrome in 2008. She received a degree in graphic design in 1984 and has done illustration work for print, television, and packaging. **34, 35, 94, 112**

**Ted Mouris** lives in the rural town of Woodstock, New Brunswick (Canada), where he knows everyone on a first-name basis. Diagnosed with autism at age three, Mouris has always enjoyed creating art. He likes cats, old cars, and KFC. **142**

Born in 1974 in Toronto, Ontario (Canada), **Daniel G. Muller** was three years old when diagnosed with "autistic features." With minimal verbal skills, in art he found a way to express himself. **130**

Born in 1958, **Jessica Park** lives in Williamstown, Massachusetts. Her mother, Clara Claiborne Park, has written two critically acclaimed books about Jessica, *The Siege* and *Exiting Nirvana*. www.purevisionarts.com/artists/jessica-park **6, 124**

Born in 1994, **Daniel Pout** lives in England. He finds art (and its manipulation of many different materials) a way to express his emotions, memories, and thoughts about the world. **108, 109**

Born in 1988, **Vedhas Rangan** moved from Delhi to Bangalore, India, in 2001. He joined the Academy for Severe Handicaps and Autism and has been a star pupil since then. He is a good artist and eager to learn new activities. **99**

Born in 1990, **Orko Roy** surprised all with his bold strokes at a time when his motor control was very poor. Some of his recent work was used in the feature film *My Own Sky*. In 2006, Roy had his first exhibition at the prestigious Nehru Centre Art Gallery in Mumbai, India. **134, 135**

**Glen Russ** lives in New York City. He loves to listen and dance to music. **15**

Born in 1994, **Noah Schneider** became interested in drawing at the age of ten. He creates computer and stop-motion animation. He has completed about a dozen short films and has received several awards. www.saucerentertainment.com **113, 121, 133**

Born in 1950 in London, Ontario (Canada), **Steven Sandor Selpal** graduated from Kent State University in 1979 with a BFA in Studio Art: Painting and Printmaking. Nicknamed "Stevo Artist" by clients, he has run Steve Selpal Art Production, Inc. since 1997. www.stevoartist.com **20-21, 144, 145**

**Rohan Sonalkar** was a young artist who lived in Pune, India. During his short lifetime, the fact that he had autism never inhibited his prolific production of quite imaginative art. His colorful work is exhibited around the world and collected by many people. www.sonalkar-art.com **46-47, 75, 98, 150**

Born in 1982, **D.J. Svoboda** was diagnosed with autism spectrum disorder with Psychomotor Retardation at the age of three. During his school years he was often picked on by others. It was from these very difficult situations that the Imagifriends were born. www.myimagiville.com **110, 111**

**Charles D. Topping**, a pharmacist, massage therapist, and autodidact artist from Millersville, Tennessee, has decided to pursue his lifelong interest in writing and illustration as a result of reevaluating his life through the prism of his recent Asperger's syndrome diagnosis. **106-107**

**Emily L. Williams** is a PhD student in research at the University of Louisville's medical school. Her focus is on neurobiological autism research. She has been drawing since age nine. Her preferred medium is mixed media, including pencils, ink, and watercolor washes. www.scienceoveracuppa.com **22, 23, 26-27, 96-97, 151, 152, 153, 154-155**

**John M. Williams** is an artist with Asperger's syndrome whose chosen medium is cut paper collage. Combining art with his passion for history, he creates "portrait" collages. www.johnmwilliamsfineart.com **116, 117, 118**

# THANKS

**A portion of the proceeds from the sale of this book will be donated to select organizations.**

The editor would like to thank all of the artists for their contributions to the book. She would also like to thank all of the family members, teachers, and friends of the artists who encouraged the creation of these beautiful artworks.

The following people have also been extremely helpful in bringing this project to fruition: Buzz Poole and Christopher D Salyers of Ghost & Company, Aaron Petrovich, Johnny Temple, and the whole Akashic team, Temple Grandin, Katie Mullin, Mari Ueda, Destini Kulik, Kelli Donovan, Dr. Pamala Rogers, Cheryl Miller, Jake Davis, Laura Stackpoole, Jackie Smith, Sarah Best, Anne Murphy, Sharon Allen, Mel Fulton, Salila Garg, Chitra Iyer, Joanne J. Millea, Maureen Doornekamp, Jayashree Ramesh, Alice Ridley, Ethel Berry, Cynthia Drucker, Kyle Goldman, Dan McManmon, Margaret Spoelstra, and Garde Rail Gallery.

The following agencies and programs were incredibly supportive and helpful—a huge thanks to all of them for their work with autism and art:

**Academy for Severe Handicaps & Autism**: www.apexfoundation.org/com-asha.php
**Action For Autism**: www.autism-india.org
**Artists with Autism**: www.artistswithautismunite.webs.com
**The Autism Acceptance Project**: www.taaproject.com
**Autism New Zealand, Inc.**: www.autismnz.org.nz
**Autism Ontario**: www.autismontario.com
**Autism Society Canada**: www.autismsocietycanada.ca
**Autism Society of Los Angeles**: www.autismla.org
**Autism Society of Ohio**: www.autismohio.org
**Autism Theatre Network**: www.autismtheatre.org
**Families of Autism/Asperger's Care, Educate, Support (F.A.C.E.S., Inc.)**: www.georgiafaces.info
**Foothill Autism Alliance, Inc.**: www.foothillautism.org
**Forum For Autism (FFA)**: www.forumforautism.org
**Fundación Soy Capaz**: www.fundacionsoycapaz.org
**Good Purpose Gallery**: www.goodpurpose.org
**The Global and Regional Asperger Syndrome Partnership**: www.grasp.org
**Irish Autism Action**: www.autismireland.ie
**Irish Society for Autism**: www.autism.ie
**Kerry's Place Autism Services**: www.kerrysplace.org
**Lebanese Autism Society**: www.autismlebanon.org
**Living Resources' Carriage House Arts Center**: www.livingresources.org/program/professional-specialized/art-center
**The National Autistic Society**: www.autism.org.uk
**Nederlandse Vereniging voor Autisme**: www.autisme.nl
**Parent to Parent of New York State**: www.parenttoparentnys.org
**Pure Vision Arts**: www.purevisionarts.org
**The Rhythmic Arts Project**: www.traponline.com
**Strokes of Genius, Inc.**: www.rcmautismnotebook.com
**Tutti Visual Arts and Design Program**: www.tutti.org.au/visual-arts
**VSA Indiana**: www.vsai.org
**VSA Tennessee**: www.vsatn.org